Reeds From Red Lips

PAMELA CHRABIEH (ed.)

PAMELA CHRABIEH

Copyright © 2017 Red Lips High Heels

http://www.redlipshighheels.com/

All rights reserved.

ACKNOWLEDGEMENT

I would like to express my gratitude to the many peoples who have been providing support to the Red Lips High Heels' movement since 2012 and to this book's project.

I would like to thank in particular the authors and artists who allowed me to publish their works and my assistant researcher Haeley Ahn for her dedication and valuable input in the editing, proofreading and design of the book.

To my students and former students at the American University in Dubai: thank you for inspiring me with your life stories, talents, skills and knowledge. Thank you for contributing to my faith in the accomplishments of local and regional peoples, and the humane realities of the past, present and future in Southwestern Asia. My best wishes are with you.

Above all I want to thank my family and friends who continuously support me and encourage me.

<div style="text-align: right;">Pamela Chrabieh</div>

PAMELA CHRABIEH

CONTENTS

Foreword (Pamela Chrabieh)	i
Watte sawtik (Pamela Chrabieh)	1
Wonder Women (Norah Al Nimer)	4
Women Bring Back Love (Katia Aoun Hage)	6
Rise (Malak El Gohary)	8
No Room for Me (Amal Chehayeb)	10
Grey Zones (Lana AlBeik)	18
Linakhruj fi layl almar'a (Frank Darwiche)	24
Tikrar wujud rajul yarfud nafsuh (Frank Darwiche)	26
The Yellow Underline (Noor Husain)	28
Coup de gueule (Joelle Sfeir)	32
Silenced (Maram El Hendy)	35
The Nile Farewell (Omar Sabbagh)	37
But it was an Important Failure (Omar Sabbagh)	38
Clasping (Karma Bou Saab)	40
To a Cypress (Katia Aoun Hage)	43
Alice's Pearls (Pamela Chrabieh)	46
A Human (Farah Nassar)	49
A Womanly Saying (Frank Darwiche)	51
Peace Strokes (Pamela Chrabieh)	53
The Saddest Story (Omar Sabbagh)	54
Are We Dead Yet? (Katia Aoun Hage)	65
Lost Masterpieces (Haeley Ahn, Masooma Rana)	66
Exit 10 (Haeley Ahn)	74

Bits and Pieces (Sandra Malki)	76
The Me I Am (Pamela Chrabieh)	83
Hurra (Pamela Chrabieh)	86
Exponentiellement femme (Maya Khadra)	87
Parcours d'une femme indépendante (Maya Khadra)	89
Ichkaliyyat al'adab alnissa'i (Nour Zahi Al-Hassanieh)	91
Al Salamu Alaykum (Pamela Chrabieh)	104
A Little Empathy Would Go a Long Way (Pamela Chrabieh)	105
Meet the Authors	108

REEDS FROM RED LIPS

FOREWORD

What influence does gender have on art production in nowadays Southwestern Asia? Does gender embody everyday life experiences, including the artistic experience? Are gendered spaces of the region Orientalized, demystified, or both? Are bodies, especially women bodies, described asexualized, passive and silent? Do local authors and artists living in diaspora reproduce totalizing or essentialist tendencies? Are power relations between the former colonizers and colonized uncovered? Has the aftermath of the so-called Arab Spring given women a greater voice and are more individuals willing to talk about gender openly? Is the view that assumes that women in Southwestern Asia are oppressed and left out of cultural debates a misconception?

These are few of the many questions I had in mind when I decided to explore the issue of gender and arts. The diversity of Southwestern Asian voices is so vast that it is unlikely to work on an exhaustive review, and this is definitely not the goal of this book; neither is it to obtain a fixed view of the gender and art relation. In fact, this book is not an essentialist celebration of identity and differences with authors and artists speaking for "the Middle Eastern Woman" – as Ella Shohat states: "We cannot reduce any community to one representative, speaking on its behalf." It presents just a sampling of a rich body of voices, thus only a glimpse at the visions, values, desires, practices and struggles this region has witnessed. It gathers the visions, journeys, statements, biographies and artworks of some authors and artists who either self-define or reject the gender binary by emphasizing the fluidity of gender and subverting gender conformity. It also displays a mosaic of languages and local dialects, visual techniques and writing styles; reeds that vibrate and produce different sounds and pitch ranges out of empowered lips.

Most of those who contributed to this collective work are part of the Red Lips High Heels' movement http://www.redlipshighheels.com, an online gathering project of writers and artists I launched in 2012 in Lebanon. This movement advocates peacebuilding, human rights and women's rights in Southwestern Asia. It involves individuals from various ethnic, religious, cultural, socio-economic and political backgrounds, living in the region and in diaspora. Academics, lawyers,

psychologists, artists, educators, employees of the private and public sectors, business women and housewives, students, men, women, and people of different sexual orientations, of gender identities and expressions, have been engaging in writing, drawing, reading, commenting on content from various feminist and human rights/peacebuilding perspectives, and in demonstrating their commitments to intermingling causes. Southwestern Asia has unfortunately been too often stereotyped, viewed as homogeneous and demonized, but the authors and artists featured in this book deconstruct prejudices. They tell stories of the rich pasts and current diversities of this part of the world. They prove somehow that the local belongings, realities, memories and histories are not to be analyzed through a binary perspective - they are far too complex, a *mélange* of grey zones and multiple shades.

The book's contributors also unveil their innermost selves. Their works are critical engagements with contexts, interpretations of self and other, and cultural memory; they materialize and visualize embodied visions and experiences. Indeed, these artists and authors write about their lives and what they see happening in the heart of their respective societies and for some, in their post-modern nomadic lifestyles. Through their texts and images, they carry somehow diverse refrains of the cities and lands they come from and/or inhabit; in other words, diverse orchestrations.

Critics may argue that the arts and real life are two different matters; that shapes, colors and letters tell us something about visual arts, literature and poetry but not about gender constructions and relations. However, for the authors and artists featured in this book, artistic and literary contents and formats serve as a barometer by which one can understand some of the numerous intricate individual and collective identities, and how gender intersects with ethnicity, religion, economy, politics, age, disability, etc.; at least, one can understand a main function of art which is to contribute to change.

<div align="right">Pamela Chrabieh</div>

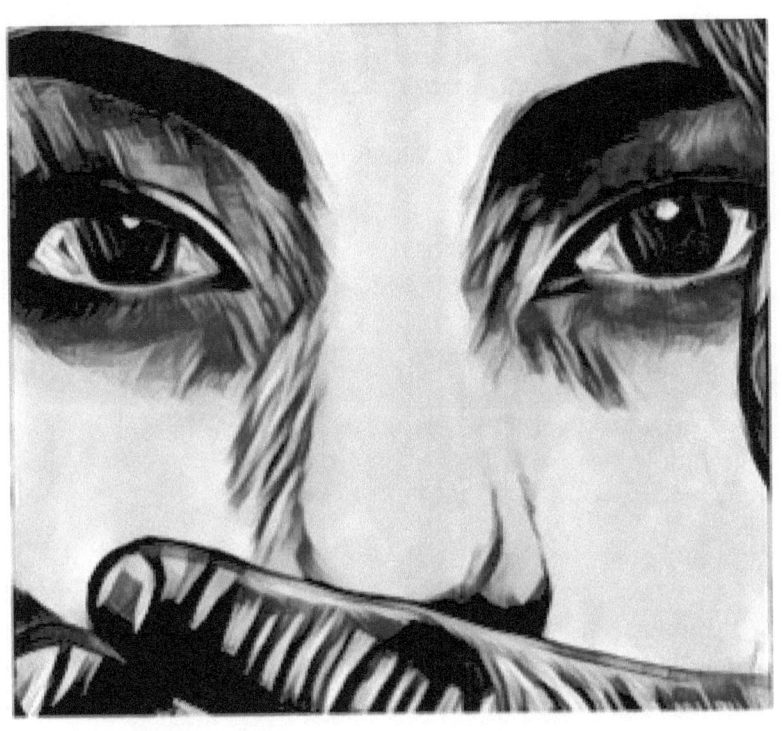

وطني صوتك By Pamela Chrabieh
Acrylic and Ink on Canvas, 2016

"Keep your suffering locked in your heart"

"Bear your traumas with sealed lips"

"Unveiled suffering is scandal and dishonor"

"The silent ones are the most observant ones"

"*Sois belle et tais-toi!*"

"You deserve high praise for belonging to the quiet type"

"You have a mouth which eats but does not speak"

"Be Feme covert"

"Be eclipsed"

"Be docile"

"Be weak"

"Be a follower"

"Serve and obey"

"Keep your voice down... Be silent"

<div dir="rtl">وطي صوتك سكتي خرسي</div>

When individuals and communities impose silence or use silence as a weapon to control, to assert power and to exclude, it becomes synonymous with alienation, oppression, marginalization and discrimination.

Oppressed human beings, and in particular women, internalize the culture of silence and negative images of themselves created and forced by others, and feel incapable of autonomy and self-governance. Most victims of the culture of silence frequently manifest reluctance to complain, even if they are agonizing, and they insist on hiding their pain under the pretext of social conventions, customs, religious laws and traditions. Despite the efforts of numerous intellectuals, activists and organizations, the culture of silence is still part of the Southwestern Asian's scenery.

Lebanon, for instance, is plagued by this culture on many levels: contemporary history, national war memory, forced disappearances, sexuality, racism, secularism, poverty, social injustices… Fear silences many Lebanese and breeds distrust regardless of their gender, ethnicity, age, religion or political affiliation. They remain silent because they believe silence protects their well-being, their families, their livelihood, and their chances of survival.

More than ever, Lebanese believing in and struggling for Peace and Human Rights are challenged to question power imbalance in private and public spheres, and to resist the culture of silence, even if many individuals' and communities' prestige and status are at stake, even if society finds it tough to acknowledge that the personal is also socio-political.

More than ever, Lebanese are challenged to bring about this paradigm shift, to question themselves, the government, political and religious leaders, to speak about their truths openly, to rethink the thinkables and speak of the unthinkables, and recognize the fact that all voices should be taken into account, including the invisible voices.

Pamela Chrabieh

Wonder Women By Norah Al Nimer
Conceptual Photography, Peace Art in Dubai, 2016

As a woman, growing up in Saudi Arabia has had a huge impact on my lifestyle, perceptions and way of thinking. Although I am not originally from this country, living there my whole life has affected me enormously such as the way I speak and dress up.

In Islam, women are given the right to speak up for what they feel and want. They are authorized to have a print in society and to influence others in a good way. However, because of the conservative guidelines most countries follow, women have limited opportunities to express themselves or to be part of their communities. Therefore, the reason I chose to go with the proverb "see no evil, hear no evil, speak no evil" is because women in my culture are obliged to act within a specific framework.

Nowadays, influential women are contributing to their societies by developing initiatives that would encourage other women to speak up for their rights. I was inspired by Palestinian artist Laila Shawa to produce this conceptual photography work. Her art speaks up for who she is and for what she believes in as a woman. She believes in women empowerment and the opportunity that needs to be given to women to express themselves freely.

Women shouldn't be judged as per stereotypes and double standards. At the end of the day, we are all human beings and what we stand for as individuals is what really counts.

<div style="text-align: right;">Norah Al Nimer</div>

WOMEN... BRING BACK LOVE!

KATIA AOUN HAGE

I thought you would never know my fears...
My darkness and those places in between...
Battered, rejected, ignored, undeserving of your sight
Voiceless, locked under armors of discipline and social politeness
Motionless, restrained movements, tied up with dos and don'ts
Separated from within: soul, mind, and body
Ripped away from the inner self

How can a woman emerge, but with the call of others
The unfailing sound of the ancestors' chants
The soft rugged touch of the grandmothers' hands
The erect figure and simple humility of the mothers' body
The endless love burgeoning in the bosom of young maidens
The amazed joyful eyes of running free-spirited girls

Women
Rise from your slumber
Awake the anger within
Shatter the links of self-servitude
Empty yourselves from destructible words
Remember your beauty
Your self-dignity
Go forth and sink in the depths of your soul
Feel your body alive again with the beat of the earth
Allow your emotions to come forth
Listen to them and give space

For in the silence
Is born your voice
And it is you who will have to hear it first
In the silence
Is born your love
And you'll have to fall in love with yourself
In the silence
Is born your life

And you'll have to offer it to this humanity
This shattered lost humanity

Arise
Reach to the circle of women
Awaiting for you to take your place
To be your true self
Recognizing your uniqueness, your gifts, and the magnificence of your dreams

Arise
Embrace with compassion
Breathe health and beauty
Bring back what has been lost
Bring back love

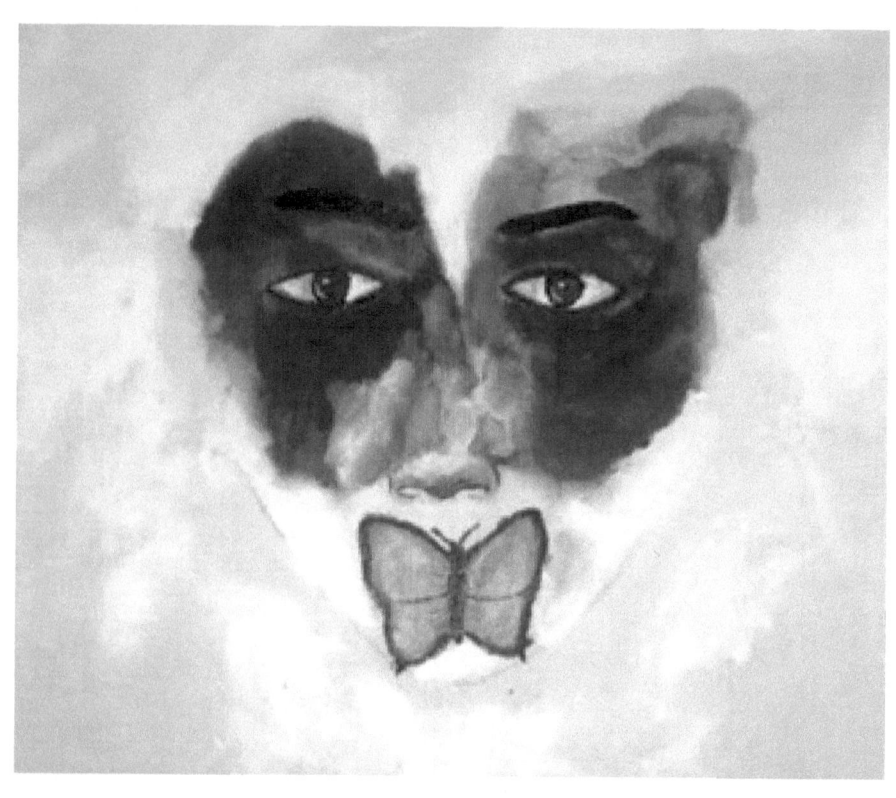

Rise By Malak El Gohary
Painting on Canvas, Peace Art in Dubai, 2016

I chose to create a two dimensional painting that represents a major issue facing our Arab society: domestic abuse.

Many women have been exposed to cruel mistreatment from family members and partners in life. Individuals and especially women who are exposed to domestic violence often experience physical, mental or spiritual traumas that can be worsen if they are not addressed. Furthermore it is common for individuals in an abusive relationship not to recall many aspects of their personalities before being abused, especially if they have been exposed to violence for an extended period of time. Also domestic violence can have a serious impact on the way a person thinks and interacts with the world as it affects one's thoughts, feelings and behaviors, and can significantly impact one's mental stability, increased anxiety, post-traumatic stress disorder and depression symptoms.

Recovery from exposure to domestic violence is possible, and although it requires addressing painful realities, it also entails discovering new inner strengths, a process that needs time, space and safety to begin. However, it is quite known that victims of domestic violence do not always report the incident fearing their partner's reaction, or fearing their reputation be compromised. In other cases, victims do not believe that the government will help, although there are many National Councils for Women and non-governmental organizations that specialize in dealing with violence against women, and can provide victims with the support they need. About 35 percent of women worldwide have faced physical violence from their partners or family members. No woman should ever go through this pain!

The butterfly is a vital part of the painting. I chose it as it's a beautiful creature with wings, and wings symbolize freedom. Speaking, raising one's voice, is the only solution women can use to be freed of domestic abuse.

<div align="right">Malak El Gohary</div>

NO ROOM FOR ME

AMAL CHEHAYEB

"You have a lovely voice, and we like the sound of your group, but you need to change your look."

"What do you mean, change my look?"

"Well, you need to be sexier. A shorter hemline, maybe... more cleavage... blonde highlights..."

That was my conversation with a club owner that I was meeting in Beirut. The gig was to open with our repertoire of French, English and Spanish songs before the main act came on stage.

I was 32, fit and attractive. My group and I had been performing for a year at various venues on weekends in order to supplement our salaries. We managed to get the dance floor hopping and the party rocking. My wardrobe consisted of short dresses and high heels.

Apparently, not risqué enough.

I had come back to live in Lebanon after a 19 year absence. Like many Lebanese people, the civil war had seen us move away to North America. I was 13 years old when we packed what we could of our worldly possessions and began the process of immigrating to Canada. I left my cousins and beloved aunties. I left my loving grandmother behind as I looked on with uncertainty at the life that lay ahead of me.

I did all that was expected of me. I graduated from high school, then went to university. My parents were sticklers about education. "You have to have a university degree. Something to fall back on if you need to," they would say. I just never pictured what I would "fall off".

Again, as expected of me, I married a man of my own circle, and five years later, I had a child. But fate had me leave the marriage shortly after the birth of my daughter. I had to return to the home of my parents, infant in tow, and work part-time while single parenting.

It wasn't long before I returned to university. With my toddler in daycare, I received my Education post-degree. I was now a professional educator, independent, self-sufficient. And shortly after I remarried.

Following a second divorce. I decided to move back to Lebanon

with my girl just before her 7th birthday; I wanted to explore my heritage, enjoy my native country and introduce my daughter to her roots.

In the second month back in Lebanon, my family and I were invited to a wedding. Little did I know that a wedding party doubles as a shopping catalogue for mothers looking for daughters-in-law. I was introduced to such a woman, who immediately took hold of my hands and checked my fingers. Satisfied that there were no engagement rings, she ooh'd and aah'd at me. I was certain she was about to ask me my shoe size as she turned me around to check my backside. I assume she was pleased with what she saw because she proceeded to ask my age, and family name.

I found this little charade amusing, and I was too taken aback at the blatant scrutiny to be totally offended. When my daughter, Nadine, ran up to me and hugged my leg, I took great pleasure in introducing her as my child.

"Youkhroub Zou'ik, Inti mjawwazi?"

"I'm divorced."

With a horrified look on her face, the woman walked away, giving me a little push.

And that was the first indication that living in Lebanon was going to be an adjustment.

Although I found employment as a private school teacher, the salary I received was ridiculously low. I tried to conserve funds by living with my parents, but by the time I paid for our personal needs, there was hardly any money left to save for my daughter's future. In January of that first year back home, I was beginning to plummet into a sense of despair. I felt disillusioned by my decision to return to my native country. I knew I had to snap out of my slump and find a way to recover from my anxiety. I needed to give myself a good shake; one that is just short of a whiplash. I contacted a musician who performed for various restaurants and auditioned as a vocalist. Our first gig was a performance at a popular restaurant for Valentine's Day.

Most of our performances took place in my hometown. Friday and Saturday evenings, my daughter sat on a little stool just off stage and sang along with me as our band opened with a repertoire of medleys ranging from some good oldies, to recent Céline Dion songs, to funky disco beats and even a couple of Gypsy Kings tunes. Our show would begin around 9pm, and by midnight, my daughter and I were safely tucked in the bed we shared at my parents' home. My

family and friends were often in the audience. The evening felt more like a family celebration than a job. Apart from earning much needed extra cash a month, the experience lifted me out of my funk and I found my groove again. I had stepped outside of my comfort zone and onto a stage, microphone in hand; belting out songs that I loved. I pushed myself to do something new, something frightening. The first few performances were the worst. My stomach would turn and my thoughts would chide me: "Why, why, why are you doing this?" "Who in her right mind would willingly step into panic mode?"

Eventually, our band was invited to perform in other areas. We were no longer just "a garage" band, having fun in our community. The stakes were changing. The fee for our performances increased, but with that came the decline of our autonomy. Demands were made to change our appearance... mostly, my appearance. I was now being asked to be someone else. Someone different. Someone suggestive.

I remember a New Year's Eve's party in M3ameltayn, where, in the middle of our set, a middle-aged man poured me a glass of Champagne. I took a sip between songs and raised a glass to the man and the audience. A few minutes later, the same man slipped me some cash which I assumed was a tip for our band. Again I thanked him and gave the cash to our band leader. Shortly after, the fellow came up to me, took my hand and escorted me off the stage and onto the dance floor where he twirled and dipped me, much to the annoyance of my colleagues. Being completely naïve, I laughed and danced away, thinking he was a happy soul, feeling the effects of the champagne and enjoying the festive occasion. When the evening was done, I faced the wrath of my band leader.

"What the hell was that all about?"

"What? The guy? Just a sweet middle-aged man enjoying the evening!"

"That was inappropriate; drinking champagne, accepting his advances!"

"What are you talking about? I did nothing wrong."

Well, was I wrong!

It wasn't long before that "sweet middle-aged man" called me requesting to meet with him to discuss work. How had he gotten my phone number? How did he get my name? I quickly deferred him to the band leader telling him to make appointments through the right channels, if indeed his call was regarding a performance. He was relentless. He called daily, and every day I asked him to speak to our

manager. Unfortunately, the calls only stopped when I stopped answering the phone.

I came to realize that I had played right into his plan, and being unfamiliar with the ways of Lebanese men, I played straight into the easy "chanteuse" stereotype.

More than once, I would meet a young man, who seemed extremely interested in me. I was certain that he would be courting me seriously, only to find that he was either married, playing the field or flexing his macho muscles. It became clear that although there would be many propositions, there would be no proposals. I was, after all, a divorcée. Make that a two-time divorcée. In male Lebanese lingo, that would translate to "Carte Blanche". I was expected to accept the advances and even be grateful for them.

I recall on two occasions where I was physically chased by males who couldn't believe that I was not free-falling straight into their beds. The first one took me to visit an old mansion that, at the time, was being used as a backdrop for musicals and concerts for the surrounding communities. We walked around the grounds where guards and maintenance workers were busy with their chores. As we moved indoors to the abandoned rooms of the mansion, my date became much more unabashed and brazen. I remember being pinned to the wall as I tried to maneuver my way around and away from him. He wasn't violent, but I can see how a woman might feel overpowered into submission.

Did I invite his advances? I might have. I had after all accepted a date with him. I had climbed into his car and driven out of town. In my mind though, I was on a date, such as the dates I would have been on in Canada. That is not to say that date rapes are nonexistent in the west, but I have always felt in charge and in control on those dates. This was a new reality for me, and I was not impressed.

The second occasion occurred at the Marriott Hotel after I finished teaching a step-aerobics class. I called a family friend from the lobby of this hotel where he resided and asked him if he would like to join me for a coffee before I head home. He was eager to take me for lunch, where he was meeting a business associate. During the whole lunch I felt like a trophy being displayed for his benefit. When lunch was done and we were walking back into the lobby, this man was convinced that I would ride the elevator with him to his room. I stood my ground. He grabbed my arm. I did not yield. People stared. I was becoming angry. He finally walked into the elevator by himself, and I took off. Needless to say, I never saw these two again

The men I rejected seemed genuinely shocked that I was unruffled by their masculine charm. As did those whom I didn't reject, and there were some. I was still, after all, a woman and a sexual being. I enjoy being with a man. I enjoy a man's attention, his caresses, the scent of his aftershave, his sensuality. But to fit in with my community, I would have to play the game. It's a pretty simple game really. The rules are as follows: One can do whatever the heart desires - the sab3a ou dimmita -, as long as one "gives the impression" that they are acting in secret. Just to be clear here, one CAN NOT rendezvous covertly - there are geographical constraints after all, (especially when one resides in a tight community) and hush-hush meetings are difficult to plan. But, to appear to be doing whatever one wishes in secret is the key to a gossip free existence. Maybe not so much gossip free, but rather gossip-light.

Well, I guess I was never one to play games. I could not bring myself to live a lie. I had love interests and I did not want to feel ashamed of my affections. There would be no furtive glances for me, no cautious hand-holding, nor guarded emotions. I was a woman who wanted to exhibit my love for another human being. I wanted to be able to take my partner to a party and introduce him as my boyfriend. I wanted to be able to indulge in my humaneness without being stealth; I was not a criminal, I was smitten. But I had to choose my battles, and some of those battles I lost.

Here I was, a woman in her mid-thirties. Teacher by day, aerobics instructor by night and lounge singer on weekends. I truly hoped to eventually settle into harmonious matrimony with someone who appreciated what I had to offer, I knew that I had enough love to bring another child into the world, and I could hear the tic-toc of my biological clock. Yet, I was also aware that my reputation preceded me like a flashing neon sign hanging over my head. My heart was broken on numerous occasions. Even if a perfect mate showed up on my doorstep and even if my romantic partner desired a life with me, this was not a choice he would be making alone. He would also need the approval of his family. In the back of my mind I could see his mother twirling me around, appraising me, only to push me aside once she knew I had been married before. And if that wasn't enough, I was a lounge singer.

I was unchaste, and what's worse, I didn't really care. I spoke loudly about my rights to my autonomy. I spoke against the double standards and the predominant sexism. I spoke of my entitlement to experience and to enjoy my sexuality. I screamed against honor

killings. I fought against chauvinism. I wanted to smash the bars behind which women were kept captive. I wanted to explain to young women how to hold their own reins and gallop towards their bright futures. But the struggles were real. Not only would I be battling against the patriarchal views of my community, but also the women who bought into those views.

Often I would see women debase other women due to their perceived "slutty" outfits. But these were the same women who had had various "improvements" in order to appeal to the same audience as those who were scantily dressed. The superficiality seemed to me increasingly absurd. The tattoo, the lip injections, the breast enlargements, the liposuctions... all for what? Why are women going under the knife to attain a standard of beauty that changes every decade? Why can't they just be themselves?

I am well aware that my personal style does not, and never has, fit the standards of beauty established by the Lebanese society, and more specifically, by its women.

"Why don't you wear a lip liner?"

"You would look great if you straightened your hair!"

"A necklace/belt/scarf... (fill in the blank), would really bring this outfit together."

"Wax your arms for heaven's sake, you look like a man!"

"Is this what you're wearing? Don't you have anything else?"

And my new favorite - and it never fails, every time I go back to visit my native country: "What happened to you? You've gained weight!"

I recall having to sit in a beauty salon where the hairdresser wouldn't do up my hair for my brother's engagement party unless he colored my greys.

Why are we bequeathing the rights over our bodies and appearances to people who don't have our best interest at heart? Why do I have to justify my wrinkles, my thin lips, my weight gain, my sexuality, my fashion sense or even the lack of it? Why does our society believe that it controls that mighty Seal of Approval by which women are stamped for passing or failing the expected beauty standards?

Once, I had bought myself an outfit that consisted of a long skirt with a side slit and a tunic that laid over top. I bought it from a shop at the local souk. Nothing fancy, nothing unique, just an everyday outfit, which I wore on two different dates.

At least Date Number One waited a few minutes before he shared

his concerns regarding my choice of clothing.

"Do you know how unattractive this outfit is? Why don't you cover your face while you're at it? You look so… conservative; so outdated. This is something a 60 year old would wear. When you go home, you should get rid of it.

I got rid of that guy.

Date Number Two, however, had a whole other tune to sing. He took one look at me and began shaming me for wearing a tunic that was almost transparent, according to him.

"You leave nothing to the imagination. I can almost see your legs through the fabric. All the men are looking at you. It's embarrassing."

I couldn't win.

Beauty, of course, is in the eyes of the beholder. I have come to understand that there are societies that are incapable of beholding mine. After 4 years of living in Lebanon, I knew I could not survive. I could not win with my clothing style, I could not win with my lifestyle. I felt unsuitable. I felt out of place. There was no room for me.

This was 23 years ago. Since then, I have come back home to Canada. I have remarried a beautiful man who admires and encourages my independence. My partner doesn't care that I was married before. He doesn't care that we don't have the same skin color. He doesn't care that I have a child of my own. He doesn't care that supper is not prepared. He cares less if I waxed my legs or colored my greys. He sees "ME". He sees a person who loves life, is passionate, and who enjoys wearing her bikini regardless of her size.

My decision to marry this westerner, however, came with a price. I have become somewhat marginalized by my Lebanese community. I do not get invited to functions that are extended to the rest of my family. I have been shamed by the community members living in Canada. Someone once said: "Kil shi wala totla3 binta mitla." The insult was hurtful; all the qualities that made up my being were diluted down to that of an objectionable harlot, because I desired to live my life as I saw fit.

As I look back, I know that this was a price that I chose to live with. I have few regrets, especially knowing that my daughter has grown to become an even better person than I could have hoped for. She carries the torch for feminism and human rights, and has just graduated from law school. As for myself, in the past few years, I have continued to grow personally and professionally. I have been

recognized for my Excellence in Teaching, received a professional certification to teach English as a Second Language, self-published a couple of books, and am now resuming my graduate studies in French. I know that I am not done, I still have the itch to pursue new ventures in my life.

How freeing it is to live knowing that my self-worth is not based on someone else's approval of me. I can be as risqué as I desire, or as reserved as I wish. I need not conform to the requests of the community around me to live life fully. I am free to be me. Crazy, naughty, demure, correct, scandalous, silly, assertive, timid, firm, soft, self-reliant and even dependent me.

When I die, I may not draw a huge crowd to mourn my passing at my own funeral, but as I go into the afterlife I will have left this playing field content that I chose to live my life according to my own rules and that any consequences I faced were of my own doing. I do of course acknowledge that my immediate family supported my life choices, much to the dismay of their own peers, but I am also convinced that I was the creator of my past and will remain the engineer of my own destiny… the trials as well as the successes.

And I am okay with that.

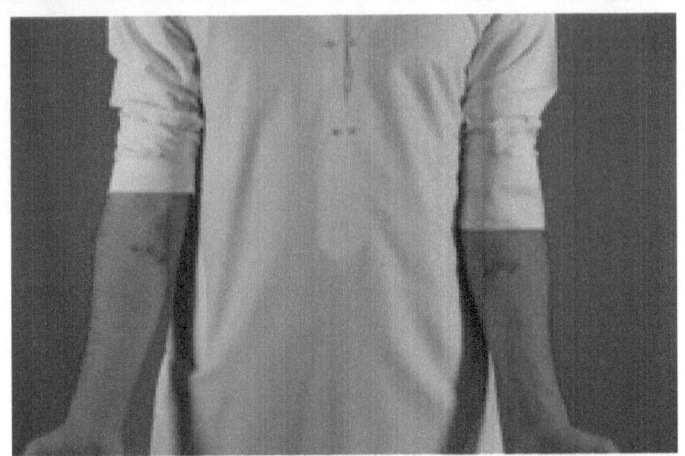

Grey Zones by Lana AlBeik
Conceptual Photography, Peace Art in Dubai, 2016

My name is Lana AlBeik. I am a media student, who enjoys art, whether it's political, stylistic or existential related, and I enjoy photography, writing and drawing. I like to tell stories through pictures, which is why I found film as a major or a career a good outlet for me to express myself.

My Piece is a collection of portrait photographs taken by me to view the grey zone of Islam and its relation with other religions or beliefs in a peaceful manner. They are around 4578 × 3275 pixels per image, and are digital photographs, taken using a Canon, 70Da. I took those pictures in a studio provided for us as MBRSC students at the American University in Dubai, with a green backdrop, then edited the background into grey for a symbolic reason. My sister, Mays AlBeik who is an artist who promotes peace, and discusses contemporary political issues, heavily influenced me. A good friend of mine who is a photographer, Ibrahim Hasan, a deist who admires Islam and other religions, also influenced me, and helped me brainstorm for the concept.

The main color noted in my piece is grey, which is the most important factor in the setting of the pictures. Grey symbolizes a zone where one does not have to take sides on things. Grey is the area where one could take something "white" or "black" and read it their own way. Most importantly, what I meant by grey is the area in which people can be religious or nonreligious in their own personal way, their own way of loving God, and still coexisting with others who choose to love God in different ways.

When I was working on the pictures I talked with every person who liked my concept and encouraged me. What was interesting is that I ended up talking about it to them, about the concept of what represents each religion, or atheism. The most interesting conversation was, expectedly enough, the one I had with the atheist, which was about the symbol I chose to use to represent his belief. While I was planning out the symbols, I was in a dilemma between using a flower, or a science book for the atheist subject. Then I settled for the flower because I figured, in the true essence of a religion, mostly Islam since I am exposed to the most, reading is highly encouraged, and learning about the world is highly urged. So I figured a flower would represent evolution, the concept of life most atheists believe in; you live, and you die human, with no other dimensional purpose or consequences. When I asked him, he said a book would be good too, without me suggesting the title. When I explained to him what I thought about the book, and how Islam encourages reading. His response was that this is what it says, but not

what people do. And I already considered that, but yet I wanted to stick with the essence and true nature of the religion, so I decided that as long as he fully agreed with the flower, I would keep it. That's when I realized that this piece is, obviously enough, from my point of view on Islam, and coexistence. So I'm trying to share my idea of peace with Islam, and how people may look something, but are something else entirely, which is why I included myself in the pieces. I get a lot of criticism, or simply baffled expressions when I say that I pray five times a day or read the Qur'an, considering the way I dress.

The most important golden rule in Islam, is treating others as well as you wish to be treated. An example of these verses would be:

"Serve God, and join not any partners with Him; and do good – to parents, kinsfolk, orphans, those in need, neighbors who are near, neighbors who are strangers, the companion by your side, the wayfarer (ye meet), and what your right hands possess [the slave]: For God love not the arrogant, the vainglorious" (Q: 4:36)

The Prophet said many things about that such as:

"Do unto all men as you would wish to have done unto you; and reject for others what you would reject for yourselves." (Abu Dawud)

"There should be neither harming nor reciprocating harm." (Ibn- Majah)

"None of you truly believes until he wishes for his brother what he wishes for himself" (Forty Hadith-Nawawi)

"Whoever wishes to be delivered from the fire and to enter Paradise…should treat the people as he wishes to be treated." (Sahih Muslim)

My main objective is to make people feel that even though someone might look like something in particular, that doesn't represent him/her, and stereotypes do not define people. And most importantly, everybody should be treated equally.

I am a Palestinian refugee of Syria and currently a resident of the United Arab Emirates. I am a film student in Dubai, and I am inspired by peace, coexistence, and humanity. Photography and film are powerful tools to connect with people, and reach out to their feelings of empathy. Media of all types is the fuel of the Arab youth and it is a tool that needs to be used to spread a message of peace and love to the future generations of our earth.

<div align="right">Lana AlBeik</div>

لنخرج في ليل المرأة
FRANK DARWICHE

أعطني يدك
افتح هذا الباب الأزرق
وخض معي في مشاعل المدينة
محارق تضحى صخوراً
وأحلام لا تعرفها اليقظة
إلا في سواقي منوية
تُقِلّ سفنُها الممحية الرجال نحو كوادر الليل الفاسقة

أعطني يدك
فلنشهد التاريخ
نسرق لحظاته الأخيرة
تلهث هذيان العاطفة
تقلّد الزهور القاتمة
في حقول العدل المحروقة
تشتمها الشمس ويتفاداها القمر

تعال معي
في هذا المساء المخضرم
تتخبط فيه ألوان الحق البالية
بين حصى المجاري وأبوالها
تعزّيني بمضيي العذب الرخيم الخافت
تتفادى أركانه أجسادُ شقيقاتي البالية

تعال نغنّي
تلك الصلوات المختلة الخالية
تعزفها سطور صراخ المومسات
بين كلمات رجال الوطن الهاتفة القاذفة
وتتلقاها أوزار مضيّهم المتدحرج نحو آفات الهيولى الغاضبة

تعال نغنّي
ونكتب
صفحةً أخيرة
تنتظرها الآلهة
منذ ارتدّ يوليان
وتردّد رفضي
في أصداء الأمم الغاشية

تعال
نكتب بدايتنا الطائشة
تعال نكتب انطفاء الممكن،
تعال نزجر
تاريخ ابتداء اللاشينية ونهاية المرأة

تكرار وجود رجل يرفض نفسه
FRANK DARWICHE

يتسلَّق الرجل المتوحّد كلماتي
فتغمره شواطئي بأساطيلها الصمّاء
وتعطيه أصدائي تردّد الحب المتردّدي،
فيجتاحه الغرور ويؤنّبه الجسد
تحت مظلّات الصيّاد العارية،
يفوتها تبختر الأسماك العمياء
وأسفار الرمال الساخرة.
ها هو يُشبع فضولَ صبره
فتفيض نطفته شجاراً متسامياً
يعالجه أطبّاءُ الوادي الأزرق
في خفايا الجذور الحمراء،
حيث يجوب إصبعٌ قطعَ طرقَه
بجع الأصوات المظلمة.
يسترح على حلمتي
معانقاً أسوارَ أسواقه المتبايعة،
محظرّاً على أظافره متعة الكأس المتأرجح،
فيسقط في ساقطةٍ
تعطيه ما تَبقّى من إله شاردٍ،
ويضيع بين أعماله
وتساقط البلّوط
متمادياً فباكيا.
أنفخ به بين أصابعي،
لعلّه جذورٌ تجترّ الهواء،

وأبصق عليه،
لعلّي أجده،
ولو لمرّةٍ،
مجرّداً، عاريا

أكتب ما أكتب في قصائدي بصوتِ المرأة بشكلٍ يدعو إلى التفكّر. بمعنى آخر، على الشعر كما أراه هنا أن يدعو إلى التساؤل عن ماهيّة المرأة، ليضعها خارج كلّ مواضيع الذات، فتراها تتحرّر وتحرّر معها أسس المجتمع.

ما تقوله القصيدة " تكرار وجود رجلٍ يرفض نفسه "، هو رفض الرجل لقول المرأة الذي يحرّره من قيود اللوغوس وهو رفضٌ للجسد وما يرافقه من زلزلة في نظام المجتمع الرافض للحرّية التي تجسّدها المرأة بالمعنى الحرفي والرمزي والروحي – فرفض المرأة هو رفض الألوهية والحياة (" الوادي الأزرق " يشير إلى البتولية وأعقابها الشائنة) والمعرفة لصالح الذاكرة التقليدية وذاكرة التقليد، بل ويقود إلى الإحباط والعنف عند الرجل، وهما إحباط وعنف تتبناهما المرأة المحافظة بدورها.

أمّا القصيدة " لنخرج في ليل المرأة "، فهي تدعو إلى نهاية " المرأة "، كما قال فوكو نهاية " الإنسان "، أي " تَزجر " بكل المجتمع المتمثّل هنا بالشوارع النائمة الخالية (من التساؤل والفكر وبالتالي الحرّية)، وتدعو إلى وجوديّة لا تضع المرأة، وبالتالي الرجل، في تعريفاتٍ وتحديداتٍ مسبّقة، بل تفتح أبواباً لإعادة تفكّر دائم بماهية المرأة ورفض أي تعريف نهائي لها.

Frank Darwiche

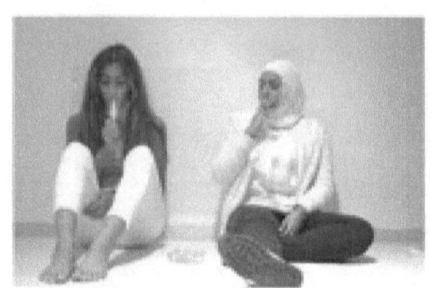

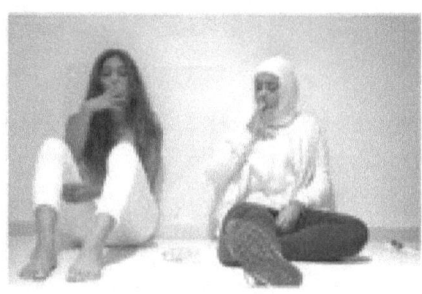

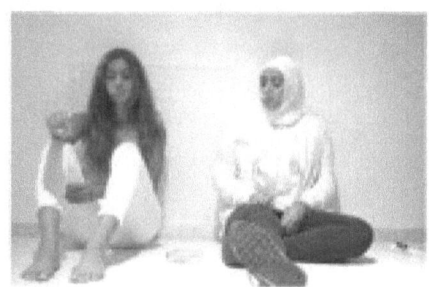

The Yellow Underline by Noor Husain
Conceptual Photography, Peace Art in Dubai, 2015

Duly named "The Yellow Underline", the series of photographs that I created is considered to be an absolute embodiment of the archaic debate that revolves around "Islam and Peace", taking into consideration the controversial argument that stems from the stereotypical mentality that many possess of Muslim women. Seeing that those individuals who have not had the privilege of being introduced to the central motives of Islam seem to link a negative connotation of the abstract ideal of "peace" to the actual pillars of Islam, I was provoked to showcase those very opinions through photography, a medium that is unpretentious yet magnanimous in the way in which it could speak volumes about the social issue that many Muslim women seem to face in the modern day.

The photographs are simply a depiction of a veiled woman who is committing the "sin" of smoking a lit cigarette - what would usually be considered as an act of mutiny against the core concepts of Islam…Or actually, that's what people might think. For a woman, who is dressed in the respected hijab is set to be living up to the expectations that society has pressed upon her, a perfect housewife who obediently and religiously follows the unsaid and unwritten rules of Islam. My aim was to tackle the meek social issue that Muslim women and men are not equal. For who in their non-ignorant mind would separate the two genders based on acts that are justified for men, but forbidden for women. Isn't Islam supposed to preach equality amongst all? Have we not grown out of obliviousness and unfamiliarity?

Inspired by the works of Salman Al-Najem, a Bahraini artist who exposes the truth behind social issues through animations and cartoons, "The Yellow Underline" aims to do the same, except in a more "adult manner", a complexity which cannot be ignored. The woman is dressed in an all-white attire, seemingly pointing out to the false purity and the dichotomy that exists between her veil and the act that she is committing. The yellow line that is painted across the clear acrylic sheet indirectly points out to the well-known cautionary tape that is used in crime scenes and other relevant scenarios, indicating the way in which society rejects and looks down upon women who seemingly rebel against the Islamic core concepts. As for the clear acrylic sheet that separates the woman from the cloud of smoke emanating from her lips, it points out to the transparency and the shallowness of such a type of thinking that society possesses of a trivial act that Muslim men commit on a daily basis. My intent is to highlight and emphasize upon the fact that women and men need to strive to equality in Islam, otherwise Islam cannot preach to be peaceful amidst tension that is created through gender inequality.

As a Bahraini artist with a background in studio art and graphic design, it is no surprise that I would eventually dabble in the art of photography as a quicker means to express my thoughts. I wasn't at all interested in the thousand words a picture had to say... No, I was more concerned with the thousand other words that were left unsaid. What exactly is my aim in art? It's simply to grab your attention and keep it. To leave you hanging in midair by the thinnest thread possible. To be able to have you become consumed with the idea that throughout our lives we have been placed neatly in boxes and set on a predetermined path in life by society. To firmly stand by the idea that the culture that breathed life into us is one that believes we are all

nothing but chess pieces in the wondrous game called "life".

The art I create is no more than a figurative mirror held in front of society. The world is filled to the rim with untouched issues that demand attention and as a connoisseur for all manners regarded as "taboo", I feel as though it is my duty to aid in exposing reality. Although I grew up in a humble and loving household, I was a child with a twisted mentality and a certain level of distaste for fiction. The fact is, the more I refrained from being pulled into the fantastical show put on by my upbringing, the more I found myself being infatuated with what was going on behind the lush red velvet curtains.

You see, many say I have my head in the clouds, but I believe that's precisely where my mind is supposed to be.

<div style="text-align: right;">Noor Husain</div>

COUP DE GUEULE

JOELLE SFEIR

Tout a commencé avec Nazira Zeineddine. Oui, ça remonte à loin. Mais en fait, elle n'a été que la déclencheuse d'un débat :

« pourquoi la femme n'a-t-elle pas les mêmes droits que les hommes ».

Sujet large, soit. Mais aussi assez précis quand même car malgré la quantité des réponses, une seule nous saute à la figure : société patriarcale, monde d'hommes = leur vision et leur désir forment et font tourner le monde. Encore une fois, soit.

Au cours du débat, une femme, Soudanaise, lève calmement la main et attend patiemment son tour.

« Ces discriminations ne cesseront que lorsque les livres – qui existent – sur lesquels les groupes terroristes se basent pour justifier leurs horreurs, disparaitront. »

Une simple phrase qui est presque passée inaperçue lors du débat – enflammé bien sûr.

Sauf que cette phrase ne me quitte plus depuis une semaine. Elle m'embête à tourner dans ma tête, à me demander si je suis d'accord ou pas d'accord.

Si on organisait un énorme autodafé et que l'on jetait tous ces bouquins au feu, cela serait-il assez pour que ceux qui sont frustrés de la vie et remplis de haine ne commettent plus des actes barbares envers les femmes – et les hommes d'ailleurs. Ou est-ce trop facile de penser que la lecture de certains livres suffit à éveiller les pulsions les plus violentes des êtres humains ?

Peut-on accuser l'auteur d'un thriller d'avoir inspiré le meurtrier ? Ou la société / sa famille de l'avoir façonné ?

Le débat de la poule ou de l'œuf quoi.

Sauf qu'en parallèle, j'enseigne dans une école catholique depuis octobre. Et j'en entends des vertes et des pas mures. La première « règle » étant : les garçons cheveux courts et les filles cheveux longs. Les filles doivent se comporter d'une certaine manière. Durant la récréation, il y a un match de basket pour les garçons et un pour les filles. Et pourtant, on leur enseigne que les filles ont des droits égaux, qu'elles peuvent – presque – tout faire (tant qu'elles se marient plus tard).

D'un côté on leur fait croire qu'elles peuvent réaliser tous leurs rêves et d'un autre on les prépare à être conformes à ce que la société veut qu'elles deviennent.

Bien sûr, ceci est très normal au final, puisque c'est le propre de toute – ou presque – école que de préparer les enfants au jeu social que leur réserve la vie. Mais quand même, quand je pense à la lutte des femmes comme Nazira Zeineddine et May Ziadé et Hoda Shaarawi et tant d'autres, je me dis qu'on a quand même bien progressé. Les filles vont à l'école, elles ont – théoriquement – le choix de vivre la vie qu'elles veulent.

Mais j'ai l'immense malheur de ne pas me contenter d'une vision, et je ne peux m'empêcher de voir tout ce qui attend les filles de mes classes : elles n'auront jamais intérêt à aimer un étranger, elles ne pourront jamais donner leur nationalité à leurs enfants ; elles devront toujours paraître belles et faire passer l'apparence physique avant celle de leur cerveau et de leur cœur ; même si elles choisissent de suivre une brillante carrière, c'est toujours elles qui devront sacrifier leur travail pour les enfants - le mari lui s'en lavera très probablement les mains (quoique bien des hommes s'impliquent de plus en plus dans l'éducation des enfants et c'est tant mieux). Elles ne pourront jamais ouvrir un compte en banque à leurs enfants sans l'autorisation de leur mari ; elles ne pourront jamais voyager si leur mari leur refuse ce droit. Elles devront toujours accepter que les hommes leur fassent des remarques désobligeantes sur leur corps, leur façon de conduire, leur choix d'habits…

Mes filles pensent qu'elles seront libres, mais ne le seront probablement pas parce que leur impératif – celui que la société leur impose – est de se marier coûte que coûte, mais d'être vierge avant le mariage parce que le plaisir… c'est une affaire d'hommes.

Mes filles pensent que la beauté est physique avant tout parce que dès l'école on leur impose des codes normatifs assez stricts.

Mes filles pensent que le Liban est un pays où les femmes ont toutes les libertés. Mais un jour elles vont devoir affronter la dure réalité. Et ça me brise le cœur.

Comment leur dire que leurs parents ne font rien pour les préparer à la vie d'après ? Qu'on pense les protéger pour les « placer » entre les mains de leur futur mari mais qu'en fait on en fait des êtres dépendants, incapable de la moindre autonomie ? Comment leur dire que non, il ne faut pas qu'elles acceptent un petit avenir à la mesure des rêves de leur futurs maris mais un futur construit par elles, parce qu'elles peuvent le faire, elles en sont capables, elles se le doivent ?

Comment faire pour leur montrer le monde du féminisme qui existe ? Comment leur parler de toutes ces femmes qui ont lutté pour un droit – jugé inatteignable, ensuite basique et leur expliquer que le féminisme ce n'est pas une tare, une injure, un truc moche. C'est ce que toute femme doit être, basiquement, instinctivement, viscéralement.

Comment leur montrer que le féminisme, ça commence dès le berceau, à l'école, et que ça continue jusqu'à son dernier souffle ?

Comment leur expliquer que le féminisme c'est une réponse à l'obscurantisme, c'est l'écriture d'une autre histoire, en marge de ces livres qui prônent la violence ? Le féminisme c'est une façon de se réapproprier le monde dans lequel nous vivons et qui nous échappe, que nous percevons de manière instinctive.

Comment leur dire que ces hommes qui les agressent, ce n'est pas normal, ce n'est pas un jeu innocent ? Et dire non ne fait pas d'elles une « coincée », une « frustrée » et que même être « coincée » et frustrée, ben ce n'est pas plus grave. Comment leur dire que si les hommes les attaquent parce qu'elles ne s'habillent pas comme il faut, ne se voilent pas comme il faut, ce n'est pas elles le problème, mais eux ? C'est eux qui sont frustrés et coincés. Et c'est là une véritable injure, parce qu'un homme frustré devient un prédateur. Et un prédateur est façonné ainsi, parce qu'il a grandi dans une société qui l'a isolé des femmes.

Tout a commencé avec Nazira Zeineddine, c'est vrai. Mais je pense avoir trouvé ma réponse : limiter la violence, la haine, la sauvagerie de certains à l'existence d'un livre, c'est bien trop facile.

Même si ces livres, ou ces écrits n'existaient pas, ces hommes les auraient inventés. Parce qu'il n'y a rien qui limite la haine et la violence. Et encore moins la haine au nom de Dieu. Ce Dieu derrière qui on se cache pour justifier les pires atrocités. Et qu'ensuite, on l'en blâme.

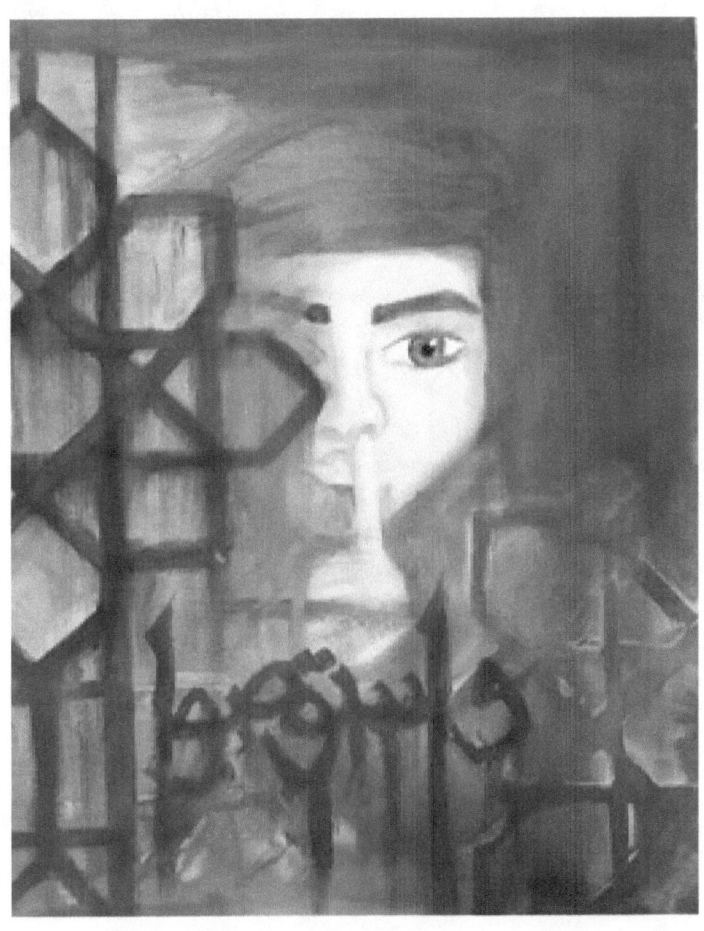

Silenced by Maram El Hendy
Mixed Media on Canvas, Peace Art in Dubai, 2016

As a Muslim Arab girl, growing up in an Arab society, I've often felt like I was silenced or not welcome to be talking in my community.

When I was growing up, my parents were supportive and encouraged me to always speak my mind but later on in life, the more people I met the more I realized how much it is frowned upon for a girl to speak up her mind in an Arab society.

People constantly link their ignorance and their tribal mentalities to Islam, as an excuse for things they are doing. Therefore I wanted to show how Arabs use Islam as a cage for the Muslim woman and how they silence her.

Women are often asked to be silenced, and their voice is considered as a sinful thing, which I personally don't believe in. I wanted to emphasize on how we are imprisoning women with our culture and mistaking it for a religion that has nothing to do with it.

I recently went to Hafeet mountain in Al Ain in the United Arab Emirates to watch the sunrise, and the gradient orange to yellow colors were really inspiring so I decided to use them. Furthermore, I believe that we always associate shades of brown and red with the Arab culture, due to the existence of a lot of deserts around us, so in a way these colors were all inspired from the environment around me, however each color has a specific purpose in the painting itself.

Red symbolizes blood or suffering.
The Arabesque shape represents a cage or a prison.
The finger symbolizes silence.

<p align="right">Maram El Hendy</p>

THE NILE FAREWELL

OMAR SABBAGH

'And neither can be certain who
Was that I whose mine was you.'
 Robert Graves, 'The Thieves'

She leaves me love as I leave her,
Two inklings in a mind that's shared –
Skin to fur and fur to bear... For there's

A wise skin-brown inside the gambit
Of these readied lives – it splays as it sits
Here in a tan café by the Nile... Meanwhile,

The ochre bulge of buildings – shoulders
Tumbling to the precipice of an antique Egypt –
Are brownish boulders that squat, square, fat

And burly shoulders bent upon this curve
Of the big river... The breeze here shines
As though it were a piece of the afternoon

Sun, the lazy gusts of the sweet Nile air
Are like our love – a heat that rounds to care
To cool... So we bid farewell – the Nile, her

Suave motion, ripples: silvery, grey and green –
A waxwork to forge her native, motive sheen
Platinum a plant on gunmetal.

BUT IT WAS AN IMPORTANT FAILURE

OMAR SABBAGH

'But for him it was not an important failure…'
 W.H. Auden, 'Musée Des Beaux Arts'

Delve the near-future, and look and see
All the rooks like rooks in the rookery –
Birds like cuckoos: not quite social…

The age that wears me, bullish, culpable,
Is not quite the age, by rights, it should be;
And I am dying for the dross, telltale

As a man ever was, or might ever be…
But it was, let us say, an important failure.
I died for all that crowed with a slur

At the fate that fate gave skin like fur –
Nothing warm with it, though. Undeterred,
The world, I'm sure, won't miss me. Only her,

Perhaps, she who bathed me
With a maddening love,
And whatever else survives

Down through the sieve
That a sad life leavens. I wish I could forgive
The mass that strode, the mass that killed,

Daily; the weight of all I bode, sailing to the last…
But at least the failure was a failure grasped, captured.
But at least the life was a life, like a question asked.

My poetry is written in a slightly unfashionable way. Not only do I most often use rhyme, whether full and frontal or half, or internal, but I am also emphatically a confessional poet. Which is to say, a lyric poet writing in the main about his own self and its burden of emotion. The music of English words and a visceral, sensual style come instinctually to me. I want poetry to perform and resound beyond its paraphrasable content. I also do not, in the main, attempt to be aesthetically challenging, or highly original in my poetic effects; no, I want my poetry, even at its most skilled and best, to be accessible to and by all. In fact, just as a poem that comes out cleanly in one sitting means that it will enter the reader in just as clean and limpid a fashion, my ideal for my poetry is for a first reading to grasp and enjoy the whole poem, with the possibility, should a reader feel the need or inclination, of delving deeper into my aesthetic, on a second or third reading. In a sense, in line with all of the above, I am an unashamedly romantic poet.

'The Nile Farewell' is poem of romance, both objective in the situation that spurred it, and subjective, in the emotional concomitants to that spatial representation. It is written for my fiancé, after a final brunch on the Nile, before departing back to Dubai. The descriptive nature of the poem is also prescriptive; implicitly, the Nile, that She, is immanently associated with that other she, my beloved.

'But It Was An Important Failure' is a poem, like the above and most of my better work, written in one quick and clean sitting. It was written from a very sad and tender mood. It is valedictory, looking-back at my life, lived to a certain extent, wrongly. But also speaks of the profit of that failure, paradoxically perhaps. Though far from suicidal at the time of its penning, it acts as a hyperbolic representation of very sour mood.

<div style="text-align: right;">Omar Sabbagh</div>

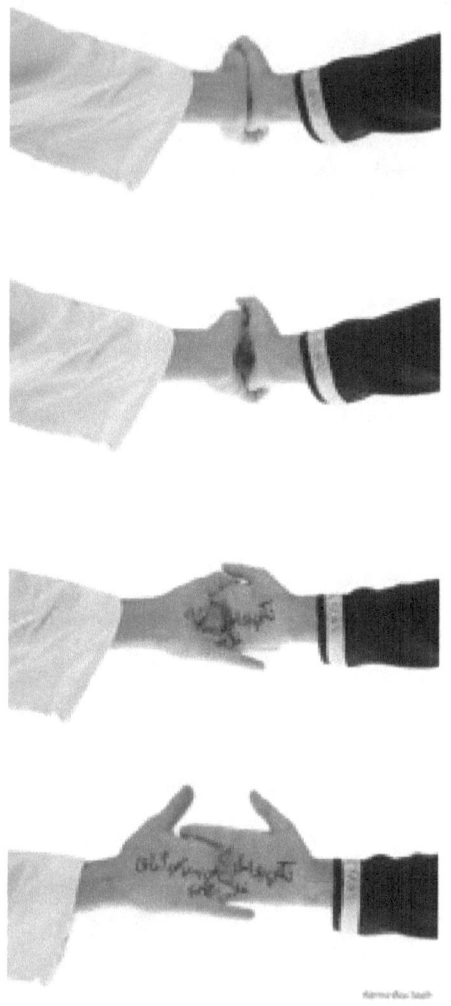

Clasping by Karma Bou Saab
Conceptual Photography, Peace Art in Dubai, 2015

In the first image, one can see two closed hands of a man and a woman, wearing a traditional abaya and kandura, held together. Due to the intensity of grip, the veins on their wrists show. If one looks closer, they're perfectly aligned. This is a metaphor of the solidarity and harmony between men and women as represented in Islam.

The second and third pictures show the two hands, still clutched, opening. One can see a glimpse of what's inside, what is written on both of their skin. What's in there seems to be beautiful, and it is indeed a production of both, equally.

The fourth picture displays the quote as is. A line written in black with a slightly red background on the man and the woman's palms. What is written is a quote of Mahmoud Darwish, a Muslim Palestinian poet:

A woman's hand in mine is enough for me to embrace my freedom.

Said by a Muslim, Palestinian man, this shows the importance of women and their role in not only the religion of Islam, but in the minds of many Muslims themselves. The way Mahmoud Darwish says that a woman's hands in his (showing equality and cohesion), can make him (a Muslim man) embrace freedom. Proving that a woman is needed to attain even the most essential things in life, because what's more important than freedom itself?

So a woman's role in Islam and Islamic societies is so important, and is highly appreciated and cherished. Furthermore, real Islam longs for equality between men and women and this is shown in numbers of ways through the Islamic way of living.

I was inspired by Shirin Neshat, an Iranian contemporary artist who teaches out her audience using both the media of photography and calligraphy writing. Shirin's works are photographs of certain portraits or even hands. She then adds the element of calligraphy by writing on top of these photographs after they have been shot. While I, on the contrary, wrote on the skin itself in Arabic letters and then took a picture of the setting and the view. Moreover, Shirin uses this medium to address women's issues in the Middle East, especially in Iran. But I have used this way or medium to send a different message this time, a message of peace and a portrait of the significance of both genders in Muslim societies. And there was no other way I could've shown the beauty of such harmony, the beauty of Muslim women's roles in life without the beauty of Mahmoud Darwish's words.

Karma Bou Saab is a marketing student at the American University in Dubai who was born and raised in the mountains of Lebanon. After moving away from home in pursuit of opportunities, Karma has found echoes of inspiration calling from Beirut. As a result, she harnessed these inspirational calls to fuel her passion towards the art scene. In addition, Karma enjoys travelling in order to indulge in cultures and make friends around the globe. She is notorious to what lies outside her comfort zone and is in constant search for experiences that allow for self-growth.

<div style="text-align: right;">Karma Bou Saab</div>

TO A CYPRESS

KATIA AOUN HAGE

I have touched
Your rugged skin
With my warm bosom
Telling you secrets
Hidden in the depth of my soul

As I ran up the hill
You saw my shadow
Drew in my scent
Leaning your face
To caress my hair
Tightly pressed on my head
Whispered in wonder
Where my curls disappeared

You did not mind
The beads of sweat
Trickling through my light shirt
Showing the woman
I will be one day
Carrying children
On hips
Swinging to the sound of the wind
Rustle of leaves

You knew what was to come
How will I shed my skins
Through dark nights
And bright moons
How I will not know you

Till the distances grew far
And farther away
Until the day I ran up the hill
To find you

Waiting
With infinite longing
For my eyes to remember
My soul to connect
Again
To the scurry little feet
The ringlet of hands
The joyful squeaks
And the divine fragrance
Incense of your holiness
Droplets of gold
Oozing from your loving heart
To the fingers of Taita (grandma)
Who picked each one
Reverently
Made glue in a pan
Books from torn papers
Stories from broken lives
Mended the sadness
With a joy overflowing
In silent whispers
from hills
Flowers
Vegetables
Different in shapes and colors
Slowly ripening under her care

As I was

Slowly learning
From her wrinkles
Of the long endured battles
The reverence of solitude
The silent conversations of being

Present

In the sun's rays
Silver lining the spider's web
Perfectly knit
On your limbs

Where I reached
To cover you with kisses
Mingled with searing tears
For it has been long
Since I ran up that hill
To fall happily
In your shadows

Alice by Pamela Chrabieh
Mixed Media on Canvas, 2016

ALICE'S PEARLS

PAMELA CHRABIEH

I was interviewed a while ago for a documentary and one of the directors' questions was about my pearls. My answer had nothing to do with eclectic styles mixing and matching old and new, luxury and humbleness, 'East' and 'West', or the importance of filling one's neck with necklaces that strike me fancy. Even if I am an artist and value fashion as a form of art, I am far from being a fashionista, and I certainly am not trying to incarnate Johannes Vermeer's Dutch woman with a pearl necklace.

My pearls belonged to Alice, my beloved grandmother who passed away a year ago…

Birth and death are the only certainties for all humans, and every culture has had customs and rituals associated with burials and with the mourning of family and friends. Between a lecture about Zoroastrian dakhmehs where the dead are left on the top of a tower to decompose in order not to contaminate the living, and this interview when I reasserted my belief in the necessity and possibility of continuity, of an afterlife connected with this life, I realized that my grandmother's pearls, Alice's pearls, do tell one of the many stories of the universal experiences of inheritance, legacy, women's memory and the power of objects to bind and unbind human beings.

Psychoanalysts from Freud up to the present have defined the goal of mourning as the detachment of libidinal ties from the deceased love object. The ego thus becomes free of its former attachments and ready to attach to a new, living person. Nevertheless, both clinical and empirical evidence call into question the 'detachment' aspect of the theory (Rubin, Klass and Nickman, Shuchter…) and propose that an ongoing internal relationship to mourning objects is an important aspect of a successful mourning.

In other words, mourning is seen "as a process of inner transformation that affects both the image of the self and of the object. It involves not the breaking of an object tie, but the transformation of that attachment into a sustaining internal presence, which operates as an ongoing component in the individual's internal world" (John E. Baker).

Some scholars would argue that mourning objects function to

preserve and celebrate the departed body, or that these objects are important because they define our existence, or that they have an embodied presence – they act as material substitutes for an absent body.

My grandmother's pearls are definitely a visceral trace of her that reminds me of the fact that people die only when we forget them; a material imprint of her physical absence and intangible presence; and more, they remind me of the necessity of reassessing my picture of the world and my place in it, of restoring possibilities in my life - the passionate sense of the potential that keeps me going -, of "making what happened incomplete and completing what never was" (Giorgio Agamben).

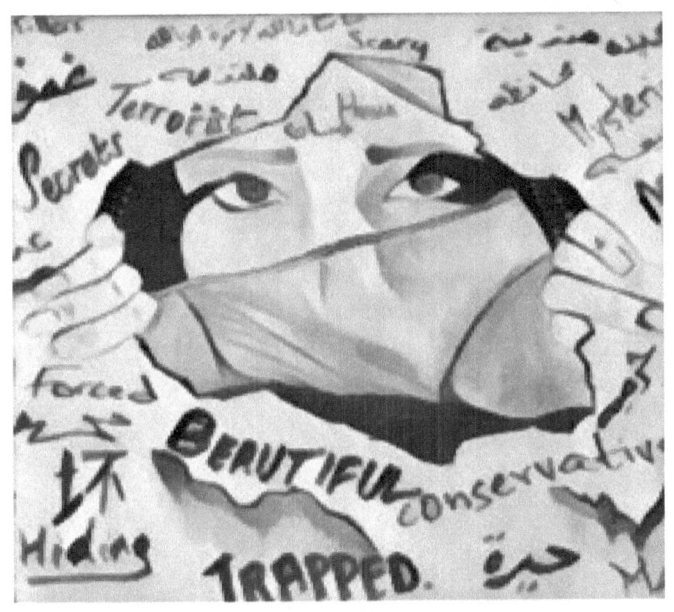

A Human by Farah Nasser
Drawing, Peace Art in Dubai, 2015

The artwork speaks about how women in Islam are labeled. In the artwork, one sees a Muslim woman wearing a veil because she follows and believes in her religion. The woman is standing behind words that people have used to label women in a veil and all those words whether they are good, bad or wrong have built a brick wall around her. As seen in the artwork, the woman is trying to break the wall and come out to the world and show everyone that she is a human like any other human.

The words used in the artwork were hand written by people from different nationalities. This particular artwork was placed in a public place with a marker and a board next to it that said "Write the first word that comes to your mind when you see a woman in a veil." The SmartLife Foundation that started a fund in Dubai to help some of the workers' children to get an education and follow their dreams inspired this idea. The foundation got people's attention quickly because people didn't just pass by and walk away. People stood and helped build the awareness by pinning a nail to the board that was set in Dubai, and this helped catch people's attention. Once people interact with something, they will always remember it. People had to be aware of how women are treated all around the globe.

I chose to put a woman wearing a veil after seeing Khaliq Alizada, an Afghan artist who spoke about women's right and wanted women in his country who wear a burka to represent it. "There's a lack of rights and injustice," Khaliq said. After asking many people, he felt that these women were feeling lonely; therefore he has added colors in some of his work to show hope and happiness in them. In his work, most of the women are either entirely covered by the burka, or they cover their face indicating sadness. I wanted to show the opposite of that in my artwork where you see the woman in veil is actually coming out to the people to tell them about who she is and how she sees herself and not as how others label her.

On the woman's forehead the word " Human" is written in red in both English and Arabic. The color red was chosen because it indicates power, pain, and it is an eye-catching color. " A Human" was created with an important message. People should stop labeling each other. We are looking for peace in Islam; therefore, Muslims should unite with one other and work to better their societies, starting with the smallest things such as mutual acceptance and recognition. We are all equal. We are all one.

Farah Nasser

A WOMANLY SAYING

FRANK DARWICHE

Bringing what is womanly within the saying that is the very expression of the non-restrained: that is precisely what I wished each one of my poems to give. But it is a giving that contains a call: the call for thought.

I've always thought that mere voicing out of critiques against women's oppression was not enough. Not only because such critiques' violence does not guarantee an exchange, but because they are only a partial outcry necessitating a stronger basis which can only be sought through a profound reflection on the human condition as such.

I could write a book on the subject of course, but I've chosen a new avenue for now: the poetic discourse.

The task was daunting, especially as I found myself unable to write such poetic works without giving them a voice that takes on the womanly as its point of departure. And so I did.

That «womanly» is not adjective, not an adverb. The fact that it has got the use of one and the ending of the other, as well as the trace of a Germanic adverbial-adjectival «lic» and an English «like» points in this case to its stretching toward an absent category to come, or a non-category that holds one of the strongest living powers or, better still, powers to live.

As such, as a substans or hupokeimenon of possiblities awaiting an essentialising power that never ceases to give meanings, that womanly determines through and through each and every poem I have written within its «saying»'s unfurling.

I have let it speak.

I have answered its call, its need for a determination in language, for a language that hints toward one of its own, for an alterity as the determining factorial and exponential deployment of what is never an identity.

Each of these poems is then here to accompany each cry seeking a discourse to break out and break in – into the blue that the structures without have become and have imposed upon the dull minds of anything human.

In each poem there is anger indeed, but it is anger-as-thinking. It

is not a mere explosion but a predetermined implosion that is meant to bring a new order disturbing and eventually annulling the present one.

There is an imposition, an illegitimacy that is proud of what it is, since it is seeking to show the legitimate's shortcomings and its slavery to long-held algorithmic constructions of the societas and polis.

My hope is that the very matter at hand, a matter held in abeyance, be held up, brought forward, transformed, taking on negations and pushing toward a founding that mocks all soteriologies and drowns them, not in some drives, but in the endless refounding of our humanity – a womanly one.

Peace Strokes by Pamela Chrabieh
Ink and Acrylic on Canvas, 2016

THE SADDEST STORY

OMAR SABBAGH

'Grief wrongs us so. I stand, and wait, and cry
For the absurd forgiveness, not knowing why.'
Douglas Dunn, 'The Kaleidoscope'

This is the saddest story I have ever known. It starts – if chance be kind to the pen – a century or so ago, with a Circassian man working on the construction of the then-new Trans-Siberian Railway. A devout (or undevout) Muslim, after years of youthful graft and ruthless tenacity, he decided to emigrate south, to the Middle East, in search of betterment. In the fanfare of fortune, what he found was love, of a kind – for a short while anyway. Within the first year of his move he'd come to marry a young, elegant and beautiful Syrian girl from Homs. She was of distinguished mien for one so young; or so I've been told. For the only sight I ever had of her was in a picture, in fading sepia, of her as an old woman, a grandmother by then, draped in diagonal layers of matt-peach and stone-colored shawls. She sits, aged there on some lit and halcyon balcony, with a Sphinx-like smile playing majestically across her face, the hand holding the hookah close-by – as though she were the proverbial still point of the turning world, which she was, or has come to be.

For in one sense, I suppose, all the sadness of this tale wends down like plump and ripened fruit from her, the bulb-burden of her tree; in another, he's the one bearing the culpable load, like a tray peopled with plates and ornate dishes of future misery. You see, that young woman's native rigor, purism and prudery have become signal, oaken lore for myself and people close to me; while the man's reactive misogyny is an equal counter in this story of biting tragedy, with its tragic bale of bitter, telltale chance. This is me, then, hoping – with all my courage mustered, and with the plum-colored blood of my pluming-claw – to find the needle in the yellow mess of all that haystack; hoping: to render the meagre dusts of all that pale and pallid straw-yellow into bonds of a deeper hue, like gold. The strained muscles and the pained ligaments of a history I wish to reap

through to a new viscera – let these pages be: an architecture of soldered tissue to wipe away the quicks of all our sufferings and the bad brine of all our tears. My name is Hector Haddad. These papers are the bruised sinews of what becomes me.

*

Stout, short and portly, grey and grizzled of goatee, he was by all the portents what one might call a charismatic man. His way of greeting any hale-fellow-well-met was somewhere between buoyant and sultry in register; his welcome, both: a groan and a tribute. And he was known to be – and the more so in later life – quite free and burly with his anecdotes. His stately pauses between segments of whatever tale he might be telling – well, they were plosive; as though the staggering of his discourse in such a manner paradoxically quickened and quickened its import. He'd a way of holding his cigarette in his right paw – the burning grueling butt poking out from the right side of his forehead, a notch above the temple, gripped in a way to accompany a kind of slow, curved and ponderous salute. It was a signal for one who was thinking, or of one who was not – being one who'd already thought too much. In the whole reconnaissance of his life, the one truly brilliant, luminous, seminal, ingenious notion, the one invention, the one unrivalled theory, came for him with the inception of true social democracy, social welfare, and its correlates in the second third of the twentieth century. He died before the monetarist revolution, and on his lips to his dying day, the name 'Keynes' or, equally, 'Schumpeter', were like golden tassels issued from the mourning of his grizzly mouth. They were the last keystones and trophies of a once-more-civilized world. In fact, by his bedside the evening he passed from the world, lay a big chunky copy of Schumpeter's own posthumous work, a History of Economic Analysis, ranging copiously from Aristotle to the incumbent dooms of the mid-twentieth century. That carmine-colored tome – above a white and bee-orange copy of Polyani's The Great Transformation. He'd never studied Economics formally, nor Political Economy, but an amateur in the best and truest sense, he dabbled with ardor here and there – far more systematic than a dilettante, far more insightful than a musty academic greybeard mincing his desiccate statistics.

Every home he ever had, or made in his later life, was a veritable

boudoir. Not so much in the sense of vermilion and black, burgundy and a wine-colored dark, but more in the sense of a space centered in a way that spoke to the very sex of things. Whatever the tones, off-white and periwinkle, creams reaching out to a naked aboriginal black, he was sure to make the place a place where an aesthete might find a home. Aestheticism, of course, was forever a category error; but he was wont to give the categorical mind short shrift. An artist darting after art, he spoke, often, of how the wheel was its very spokes, not the destination. The didactic sense was always a non-sense. The word 'fabulous' mixed with 'miraculous' like Siamese twins in his chinwag and parley – the fable of a miracle, the miracle of a fable. Though he never – to my knowledge at least – knew the purport of the term 'chiasmus', he was, resolutely, one of its denizens. As though he lived, and turned alive, by the friction of a grinding symmetry, or that symmetry that betokened abyssal friction. A man for all seasons, from whom my lineage descends – he would have bellowed, I imagine, at the near-homonym of Rambo and his other.

(Speaking of stallions, just the other day I was teaching the meaning of a heroic quatrain. You know, the four-lined stanza whose rhyme-scheme is 'a, b, a, b'. And not only was it the too-evident trope of the Hollywood romantic comedy, whereby the happy-ever-after is pitted at three-quarters by a rift or a misunderstanding, but 'Rocky' proved a good dose. If that fist-bickering chap won in the first round, well, the movie, even for Hollywood's hollow fare, would be crap. But, to lose fourteen rounds, and then stage a comeback, well, that was more of the timbre of sturdy rock. You have to lose your-self to find your-self, I was telling my class; it was something to do with Christ...)

So, yes – for all the final, ensuing sadness of this tale – for the while, he'd a grand and billowing sense of humor; and yet, as I've intimated, he was earnest at the same time, for the right reason. Reasons like his son, my grandfather. Indeed, to load the dice a little with too much double-ness, my Jiddo was a trained logician, who'd managed to scramble from the Jordan where they lived at mid-century, roughly, to the pinpoints and cloisters of Oxford. His doctoral work, I believe, centered on the problem of 'Universals.' And he too, for all his erstwhile rigors, was a funny man (for all the tidal woe that was to come, whetstone and knife). To this day, I

recall, a brainy four-year-old, being asked where exactly 'White' was? I think I answered by pointing to the tablecloth. From which point, till my sixth year, when he too passed-on to that roulette in the sky, he always dubbed me, wagging a dolorous finger, those rare times when we saw each other: 'my grandson, the apostate; my grandson the nominalist!' Sometimes, in his snoring slumber, he would wake his somnolent self by shouting with eviscerating verve the proper noun, 'Quine, Quine!' Dear old man, he died a Platonist, and on his grave, as requested, we'd embossed the line from Whitehead, about all philosophy being a footnote to Plato.

Marrying the latter's daughter, my father had anything but the temperament of a Platonist, and was by fiat I suppose a convinced pragmatist. To my knowledge he'd never read William James, or those of his ilk, but he trundled through his life making-do, and making-free. Not that he'd not the old, sparkling tendency towards logical thinking that has marked the annals of my family with a labile flame – but that his logic was of a more mundane, less airy kind. I tried once to explain to him the difference, to be found in Logic from the early twentieth century, between external and internal negation. How words like 'yellow' only have negations in 'not-yellow', whereas words like 'good' have both: 'not-good,' and 'bad'. He didn't follow, or didn't trouble to, scenting a business too Byzantine for his taste; though my mother did. And my mother, without knowing it, was Plato's first lover; as though 'Alcibiades' turned kosher and halal.

Numbers were ever her siblings and friends. She'd phonebooks planted in her mind, like inevitable trees. She might recall some so-and-so's brother's wife's mobile number with the least draft of effort. Her brain was quite mighty for a woman's. And of course, or that said – George Eliot, I think – clever mothers: clever sons…

So. And all a timely tangle…

Now we get-close to the spice and nub; now we see and see and see the true drapery of the fruit, plump and bright with its bright and bad corsage. From the tips of these fingers we'll find the rent in the fabric, and wail, and keen. A mind not to mind, a prince in his sagely feathers – poor chap, he was, somehow, too passing to care how or where or why the world ruffled. And so: he painted his life of cornices, palaces, like a prat – quite like – into dankness: the darkling-

grey of dungeons.

Let the rats – scurrying here and there, in bone-wet and ropey-grey – behold the rum-ness of this royalty, of dread and danger and loss. They may gnaw at his chains, in sympathy, big-bellied and swollen with a sour camaraderie – but they may see the light of day, where he can (k)not.

The old Circassian strain, then: the old Circassian strain.

*

She was too gripped to the idea of heaven to live a workable mortal life. Though close to a hundred years in distance, I see or have seen the same rigor mortis in my own mother – genetic epigone from that time of feline Syrian youth. You see, the Circassian man and the young and nubile Syrian girl were ill-matched, or proved to be so, in the long-run anyway. After hatching their batch of children, four to be precise, two girls then two boys, it was for all intents and purposes the shut-up of the shop – its shutter clanging down with a raw, raucous, metallic sound, to begin the long journey of rust. The woman turned frigid of a sudden, and the man: enervated. After birthing her children, duty to her mind now done, she was wont to lock herself in her bedroom or the bathroom nearby, whenever her husband returned from work – refusing to sleep with him or share in the married-staple of visceral endearments. The tenderness, the tenderness we all need, went dead and doubly-so: a dodo. Poor chap, perhaps it was only inevitable that he'd take a mistress, and then a string of them.

It was from the beginning of middle-age, then, that Mohannad began to read and read copiously, mixing a love for art with a more general interest in the humane sciences. Even with mistresses, in-tow, he turned to bookish sports to salve and solve the new lacuna in his erstwhile marriage. Thus, in one sense, a sense with a sharp and stinging tail, the long trajectory of intellectual habits and intellectual loves derives – and with true tragic fruit – from the prudery of a young woman who found herself married to a man she didn't, in the end, quite love. I can see my great-grand-father in my mind, banging with long futility on the door of his wife's bedroom, begging to be let in, begging for succor from the daily hardships of work. But, like the

proverbial taxes, what leaves through the door, enters through the bedroom-window. Just so, a long lineage of dangerously-curious and hotly-harvesting minds finds itself resumed here, in these dragon-colored talons – writing no doubt with a bit too much flair to be hale or toothsome; hoarding, if you like, his treasure.

*

In no special order, then, I start with a record of one of my maternal grand-uncles. He lived to the ripe old age of ninety-five, which by any account is a bloody good innings. A poet of some renown in Syria, he was dubbed with much tenderness by fans and friends alike, 'Al-Mutanabeh,' after the iconic Arab bard. The first and most pressing occasion for this flattering nickname was due to the fact that he'd reams and reams of both classical and contemporary Arab poetry readied on the tip of his tongue on all and any occasion, to be recited with incisiveness and aplomb. He started a batch of different literary magazines in early to mid-career, and came to be known as quite the lyric poet. He disowned politics, finding music in feeling, and feeling in music – the world of politics being a thing less seamlessly brilliant, far, far less fluid, lucent; the world of politics – sordid, for being, so to speak, read from left to right, from top to bottom. For the law of gravity, like the law of poets, is more, much more than the steady, staggered increments of its mathematical proof.

Indeed, a few days before her own passing, his sister, my grandmother, broke her, by-then, year-long silence to tell of his own long-wrought silence in the last years of his life. I see her now, her skin white and rose-pink and sallow, seated on the couch in her Beirut apartment, the TV blaring futile news which she'd never hear due to her deafness, her legs sticking out like plump bales of hay and resting on the cushioned table placed for that purpose in-front. It was a shock to both my mother and I, to hear this ninety-four year-old woman, beloved by the both of us, suddenly speak, like a hinge long-forgotten by oil. And it was also, in a way, slightly comic; because when she opened her mouth to speak, a bit like a novel, she started in medias res, as though continuing a conversation just recently and abruptly stopped. As though during the long year of preceding silence, she were holding a monologue in her mind, which only now, by vapid chance, found its way into waves of sound and

material volume. She said it with a strange twinkle in her eyes; and with a tinkling sound in her voice – her words like orphaned drops of water tinkling into a still pool.

'He was a good man, my brother. But you know, for the years before he died, not a word – and this was a man who was a king of words, a poet whose syllables flowed like rustling fountains from his dear lips. I think,' and she looked upwards a the ceiling, ponderous and slightly bathetic for us, watching, suddenly rapt, gasping in our minds to hear what she'd to say after all this time – 'I think it was because he had lived and imagined everything there was to live and imagine; I think: it was because he'd seen in life or in mind all there was to see; I think, simply, he'd nothing more to say.' From silence, then: to silence again.

And, cinematically, with a touch of weird absurdity, she herself died a few days later. She was on the toilet I gather, being helped by the maid and helper; and half-way through her purging, the held hand went limp, the seated, crouched body, collapsed, like a heap or sack of straw. She was gone: to that great orchard in the sky; that prose-less, poetic bower.

She was a wonderful woman, truth all told. She herself had academic ambitions, which – as we are about to see, as telltale legs of this legacy – was a kind of downfall. She was educated to Masters-level, in the field of education, having done her post-graduate thesis on that great educationalist, Dewey. She specialized in Arabic literature, with a focus on the same, but as catered to children. I found wonders in her library after she passed – Sartre on the imaginary, a first edition Faber, of Eliot's essays, and many other juicy things besides.

Her husband, the logician, was insuperably affable, personable. I've seen pictures of him in sepia and black-and-white, and his beaming face is like a grand definition of graciousness and welcome – glad jewels in and of his screwed-up eyes. As I gather, however, by the beginnings of middle-age, their three children born and near-raised, they'd divorced, primarily because the man with the glee of that inevitable rictus couldn't quite stomach the forthright ambitions of his wife. She was a strong and bellowing woman all the way through to old age. Their three children, two boys and a girl, my

mother, survived the break, none the less; but with different fallouts. Logic, for my grandfather, meant a woman might be very intelligent, brilliant even; her place though, as in or by some sturdy syllogism, was in the home. My grandmother retorted, if you like, by considering that deduction more of the timbre of a sophism, waylaid in the waylaid agora.

The tale is told (and I believe it), that when my mother was born – with a true-milk-white-sheen beveled and splayed like fluid layers of silk in and across her skin; with her equally-Circassian emerald-green eyes putting tropical seas to shame – the neighbors would heckle my grandmother and bang on her door just to plead to get a look at the fair-haired, green-eyed angel; as though she were an anointed one; as though a future of sadness (mine own) incumbent on being much like an anointed one – but so-badly by the fates – were present there, in that foot and a half of beautiful girlish baby.

Just so: glad, newborn surprise becomes – with time and prone, due retrospection – a deathly-arrow pinning and pinning the very purport of sky; the beeline from Circassia, entailed.

*

For all the shining bombast of her gilded golden aureoles, my mother once said to me that, though she'd never hated, really hated anyone in her life – there was an exception.

'My father was dying in Baghdad, while we, your father and I, were in Beirut. He was attending a conference at the time, when he fell suddenly ill. I'd my hands full with your two sisters, your brother and you. I didn't know, you see, how serious it was; that my father was on his deathbed. Of course, the right channels in Baghdad had attempted to get a message sent to me. But the messenger chosen was a real bitch....'

It was the first and last time in my life I heard my mother use that word.

'She was a jealous type; she resented my close relationship with my father, her uncle. So she delayed and delayed – lying like a feral animal all the while – sending me the telegram. And so, when,

eventually, I flew to Iraq, I was too late: my father had passed-on. That woman is the one woman, the one human, in all my life, gone and to-come, that I have ever really, really hated.'

She was in the kitchen of our London home when she told me this, a burgeoning lump in her throat. It was one of the first glimpses I'd had of my parents, as mortals, flawed and floored like the rest of us.

Cognate, I remember when her younger brother, my uncle, died. It was abrupt – and bruising on the sometime-butter of our lives. He'd had a sudden aneurism at three o'clock in the morning, visiting the toilet in our London home, where he was sojourning briefly. In my slumber – before, that is, I was woken up by my mother, weeping, blubbering out words of creased dismay – I'd heard a loud bark of 'LAH!', 'No!' It must have been my father who'd first found the felled body, bleeding a crimson pool from the skull. But I only recalled that hoarse interjection later in the morning while the police where taking the body away – like a delayed decoding. I see my mother still, seated much like a little girl, yes, like a lambent child again, bunched-up in a seat in our living room, trying to hold back the forceful burden of sobs. A policewoman crouched down and stroked my mother's back in solace. The next day we buried him, and I was able to toss a fistful of wine-dark earth onto the coffin, lowered a few feet down, draped in good Islamic-green.

True, they'd not always had the best or smoothest of relationships; Bisher – unlike my mother and her elder brother – having been most affected by the divorce of their parents. But the love was there – proven by the harsh-lit aching that racked us all. Often she would berate him, the now-deceased, for his bawdy habit of listing, even then, in his sixties, the rigmarole of all his sexual conquests, a bachelor at large till his dying day. But the man, for all his betimes coarseness, was deeply-kind. His passing was the passing of a man who'd millions logged and stored – but finally lugged, faithlessly – in his heart.

Bisher's, however briefly, is a tale to tell; needling-ly so. He'd inherited, you see, the logical panache of his father. OCD was how that rigor played itself out in my uncle's psyche. Not the most original of thinkers, he was effortlessly, overly systematic. Much like

his grandfather, he'd a penchant for economics, and like his sister, my mother, but with less daggering-stealth perhaps, he'd a head for numbers. And he'd worked for much of his life in the Gulf, as an economist and financial consultant. However, by the time he'd reached his sixties, when all his health problems – diabetes of a singularly pungent kind, heart disease, among other ailments – came to a head, he was broke. Apart from the nervy gambling on the horses – a habit ingrained with verve from his middle-life in the Gulf – he'd spent his last coin on a kidney transplant and all the fallouts of such.

His tale, like my own, is woe-tidal and tragic; for in the seventies and eighties of the past century – when a troupe or more of young Lebanese businessmen were on the brimming scent of the new reserves of all that new oil-money – he'd been a willing middleman, and without pay. From the kindness of his heart, from all that he took to be nascent duty, he'd engineered the various meets-and-greets that were the sine qua non at the time, in that place, for getting contracts; contracts which paid in the millions and millions. So that by the time of his sixties, when he was working a day-job that paled with his previous fortune, and that paled, to boot, with the retired leisure of all the millionaires he'd aided – the man was miserable, and frustrated, inarticulately frustrated.

He was moral to the point of absurdity; to the point, in fact, of being deeply anti-social. Where my own father, a man of honor, might have the diplomatic skills to alleviate any tense or awry social situation – Bisher, when seated, say, at one of those rare dinners he'd agreed to attend, would bark out the word 'Bullshit!' and storm off in a ruffled huff, when seated next to a cretin or some other person who, evidently, was full-of-shit; or, harmlessly no doubt, engendered mild-mannered fibs. And there were many such: ornate, sparkling tables of gormlessly wide-eyed Arabs.

He was a good man betrayed by the very bulk of his open and opened heart. May God have mercy on his obsessive-compulsive soul!

The "Saddest Story" short text is certainly not self-contained; it remains the opening of a longer project. It is generically slippery, in that some of it is based on real family history and some invented; and some of course, a combination of the two. I like to think of it as a fantasised version of a family past, a family lineage, only begun here, which dramatizes my own interests and, in the end, my own fate. If you like, it is impressionist in this sense: the truth is not factual most of the time, but imaginatively truthful. Indeed, the whole term 'saddest story' is an allusion to Ford Madox Ford's masterpiece, The Good Soldier, though this writing is nowhere near the same kind of writing. None the less, I suppose it is true that in this opening chunk, as projected further, the whole notion of 'fate' and its 'goodness' or 'badness', is the issue I want to descry in this project, if certainly not solve. To conclude, it is a warped version of a family lineage, which will reach the present; and that warped version works hyperbolically: it adds resonance and flavor in an imaginatively truthful way, not fanciful in any sense -- to tackle some basic questions about determinedness and chance in the fate, tragic, of one individual inheriting that past, directly or indirectly.

Omar Sabbagh

ARE WE DEAD YET ?

KATIA AOUN HAGE

The puss oozes from many places in a body ravaged by a cancer inherited down generation after generation. The smell lingers in the air of rotten tomatoes, half emptied bottles of shampoo, a leftover kebbe. The flies feast on gangrene, it celebrates with a nightmarish buzzing the filth that covers a society deadened to its own illness. The rats eat away with no restraint, the lost beauty of a ripped *signé* shirt or the exquisite taste of a white wedding cake. Rats populating corners and alleys occupied by ghosts, unaware of their doomed existence. Minarets and bells call to awaken, knock on the door of consciences tucked away neatly in closets of righteousness. A gong sound, emptied of its many vibrations, barely moving the muck so thickly resting on the waters of rivers and sea.

Shouts of youth walk out in the streets like mirages of laughable acts. Hope is squashed as soon as it peaks its head from under the thorns. Flowers are trashed as soon as their fragrance invites to be alive. Fingers are broken as soon as they learn the ecstasy of molding a new future.

But I have seen trees sprout when all the fields have been cut low, moss and grass pop out of stones, butterflies roam desolate lands and one crow croaking laughingly at all the emptiness of a valley of death.

From the ashes of desolation, we emerge to heed the call of our lost ravaged body. We refuse the bandages of empty promises, pouring our compassionate hearts into every wound. Against the tip of knives that has disfigured our souls and dismembered our thoughts, we flow like an unstoppable river of love that heals us and them. We dance, we sing, we write poetry on top of houses and in the darkest recluses of brothels, until light shines again from our pure hearts, our searing tears, our unwavering will to exist and be.

LOST MASTERPIECES

HAELEY AHN

ILLUSTRATED BY MASOOMA RANA

She rubbed her palm against the ground berry pigments, and in one decisive swing she slapped her handprint proudly next to the horse she drew earlier. The men were roaming in the wild, chasing down game. It was her responsibility to pain them good luck.

Then she disappeared from earshot. Supposedly, she sculpted vases, painted battle scenes, tiled mosaics...but no one spoke her name. Her male colleagues left artistic legacies of perspective, symmetry, and balance, to be visited and revisited. But when she died her art died with her.

Then, she could only participate in art as the subject, never behind the easel with the paintbrush. She was beautifully passive, passively beautiful. Those devoted to religion were given the privilege to become monastery limners. But it too much to ask for both a family and a career.

And the trend continued. Beyond the prominence of one or two painters, she was confined to the home, belittled for her small brain size, her physical frailty, her apparent lack of intellectual capability. Western art entered a new golden age with the hearkening of classical themes, but amidst this time of progress, she remained an outcast.

The machines overturned the social hierarchy, and suddenly she was encouraged to pursue art, the art she was made for: crafts, such as pottery, embroidery, jewelry making. All that she made was, of course, still inferior -- a mere emulation -- of the true art of the men. Only those in the Academy were allowed original thought. She wasn't accepted at the Academy.

Finally, the hierarchy that had persisted for so long was openly challenged. For the first time, she asked: Why have there been no great female artists? She dug through history to salvage the stories of the few women that preceded her. And near the turn of the century, she was accepted as not an anomalous woman but a viable professional in her own field.

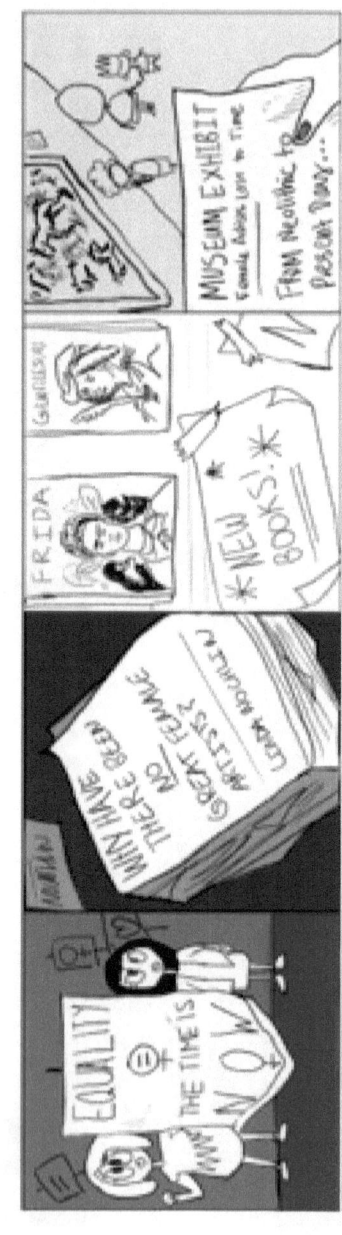

And today, in 2017...how is she now?

Masooma Rana is a Senior at the American School of Dubai and is seventeen years old. She has lived in Pakistan, the United States, Canada, and Dubai. Masooma has had a long time appreciation for the visual arts since she was very young. She usually uses pencils or paints as her main medium, but she has also recently taken up digital art and photography as well. Masooma loves how she can express herself through simple brushstrokes or capturing a single moment through her camera lens. She loves to create for others, be it a complex stage set for a play or an illustration for a friend. She works to improve her skills in the field of digital art and photography, and hopes to make great achievements in those areas. Masooma considers herself a feminist and one of her favorite artists is Georgia O'Keeffe.

<div style="text-align: right;">Masooma Rana</div>

EXIT 10

HAELEY AHN

On May 17th, 2016, a Woman was stabbed to death in a public bathroom by a Man in Seoul, South Korea. She was 21, only 4 years older than me, taking a break from karaoke with her friends next door.

He said Women had always belittled him.

So He loitered around a unisex public bathroom with a knife for an hour, walking back and forth, back and forth, waiting for her, any her, to walk in. He let six men through, and when he saw the seventh was a she, he pranced.

His murder was a crime against a Woman.
His murder was a crime against the Women.

We built a mosaic with sticky notes on the walls of Exit 10 of Gangnam Subway Station, the closest landmark to the bathroom. It became a site of mourning, but also a site of conflict.

Women identified the crime as misogynistic.
We die because we're women; you live because you're men.

While men, not so much. A man protested in a pink elephant costume: The criminals aren't the carnivores, it is the animals that commit the crime.

Not many were convinced.

I happen to live in ten minutes distance from where She was killed.
I happen to frequent the karaoke place She went to.
I happen to have washed my hands in that basin Her blood trickled onto.

By the time I returned to Korea from Dubai, it was my summer holiday, three months from the murder. The post-its had fallen off, the media had moved on to new celebrity scandals, and the Men had forgotten. But not us.

Now I'm afraid to walk into a bathroom outside without a group of other girls. What's a public bathroom across a karaoke place to my friend Max is the Public Bathroom across the Karaoke Place to me. I can lie in my bed for hours, eyes closed, as I think to myself: That could have been me. That could have been me. That could have been me.

I don't think Max loses sleep for this same reason.

But what is it that I'm asking for? Do I want Max to stay up the night, thinking the same thoughts as me? Do I want him to share my fear of public bathrooms? To colour Exit 10 with the same sticky notes?

Not even.

I just want him to acknowledge that His murder was misogynistic. I just want the Women of Korea to not be alone.

BITS AND PIECES

SANDRA MALKI

Forget Me Not

Maybe I am sad
When I get reminded of what I lost
Maybe I am sad
When I am reminded about the cost
Of your betrayal
Do you remember me?
Mother dearest and father too
What did I ever do to you
Was it because I stayed true
To someone you never knew
Me?
Believe it or believe it not
I used to call myself "Forget me not"
That is the flower I always felt to be
In our complicated and loveless family
Can't you see?
Maybe I am sad
Because you are not sad
Of losing me

Mother Dearest

Two nightmares so far
Two nights where I crumble and fall
Bad words I hear you scream
You really hate me in the dream
But you hated me before as well
The dreams are just reminders of your hell
When will you stop effecting me?
When will your terror let me be?
Will I ever be free?
Two restless and sleepless nights

Two nights where I relive our fights
I hear you curse, I taste my tears
You are one of my greatest fears
Why are you still in my head?
Do you remember when you wished me dead?
So please mother if I may
I beg you to stay away
Will I be free from you today?
What is a family?

Families are not perfect
How I wish it wasn't so
Families should be a foundation
I read it some place, you know
Families teaches you to embrace
How I wish it was that way
The family should be the place
Where you would like to stay
I have two mothers that haven't given birth to me
I have sisters and brothers of another blood than me
I have a father with a crushed heart and he sometimes forgets me
He understands my brothers but never seems to get me
I have no uncles no aunts and not even cousins
To me my relatives are just like broken promises
They keep their distance to keep their deepest secrets
And their hearts are as dry as the driest deserts
Families should stick together in joy and in pain
Families should be together in sunshine and in rain
So next time please include me in your family game
So that I could feel that I'm a part of the family name
But until then
I think I'll stay the same

Sadness in Disguise

A recent picture of me
Can you tell me what you see
Can you see I had enough
Now I have to be rough
Hide my weakness

Like an actress
Acting careless
In my crises
I play tough

What is Normal?

Can anyone tell me the meaning of "normal"
Can you describe it to me?
I looked for it page by page in my journal
No "normal" was found as I could see
So without it in my past or nearest week
How will I recognize it if it came along?
Who shall I ask or where shall I seek?
Can you describe it without being wrong?
Maybe I should ask a dictionary online
Why should you be my teacher?
In mathematics it means a regular line
In biology a natural feature
But what about personality or brain?
Should I look for a psychological meaning?
It explains that a person should be sane
Oh that must be a wonderful feeling
So sane, natural feature and a regular line
Is that what "normal" is today?
I wonder who without any doubt can define
What "normal" is in any way
What is "normal" and what is not?
And what is right and what is wrong?
What is ugly and what is hot?
And what is weak and what is strong?
If "normal" is what you feel today
Could we have met yesterday?
I thought you were out of your way
When you took my freedom away
Who is "normal", me or you?
I just wouldn't have a clue
Try to be honest and true
Tell me what "normal" is to you
Can you now see my point of view?

In our family normality is taboo
No one uses the words "I love you"
But maybe that is "normal" too

On My Own

I will make it on my own
I will face it on my own
I will feel it on my own
I will beat it on my own
What is sanity
In this madness
What is security
Without happiness
What is family
Acting careless
What is opportunity
Without second chances
I'll trade madness with happiness
And security with sanity
I'll learn that acting careless
Doesn't make a family
I don't need more second chances
Because I have the opportunity
To reach greatness on my own
EVENTUALLY!!!

A Soon Mended Heart

Is love so complicated
That you suffocated
The love out of me?
Is love so animated
That you fabricated
The love you had for me?
Is love so intoxicated
That you devastated
The love I had in me?
I refuse to be violated

I know how you operated
To gain power over me
I am no longer obligated
To be dominated
I am not you, I am me
I am now motivated
To be concentrated
To set myself free
Because you see
Love is really uncomplicated

LAW

Law
Law btefhamouni
Law
Law 7abbaytouni
Leh jara7touni
Law
Law 3al deniye jebtoni
Law
Law kento sa2altouni
2abel ma tezlemouni
Law
Law ma kabbartouni
Law
Law ma akhadtouni
Yaret ma gharrabtouni
Law
Law bi baladi taraktouni
Law
Law kento nsitouni
Ken ghayrkoun 3allamouni
Kent kberet e7lam bel 7eriyye
W koun shoje3a miyye bel miyye
Kent bghanni nashidi sebe7 w 3ashiyye
Kent bettalla3 bel mreye w a3ref min hiyye
Hal benet el Lebneniyye
Law taraktouni
Ma kento t7ewlo tghayrouni

Ma baddkoun bent el swaydiyye
Bass ana sert hiyye
Balki mesh 2asliyye
7atta law
Bass 2ana hiyye

Ya Rabb

Ya rabb 2assili albi el makhdou3
Kermel ma ydall ywajje3ni
Ya rabb bikaffi enno mawjou3
Ma tkhalli ba2a 7ada yejra7ni

2a2rab el nes ba33adoni
Be3ouni w be3o el nes kamen
W sho ma 7kit balki ma betsadd2ouni
Iza halla 3refto, ana kent 3erfe men zaman

Adde sarlkon makhdo3in
Youm? Shaher? Senten?
Ana men ana w tlett snin
3erfe enno ma fi mennon 2amen

Bass ma3kon 7a22, ana ma3kon
Kif ta ta3erfo 7a yeghdor el 2arib
Ma ana kent metelkon
Entebeh bass men el gharib

Tle3et gheltane ktir
Njabaret ekbar 3a bakkir
Sert shof w esma3 sho 3am bisir
Bass bel ekher dall 2amali kbir

Men hek b2oul

Ya rabb 2assili albi el makhdou3
Kermel ma ydall ywajje3ni
Ya rabb bikaffi enno mawjou3
Ma tkhalli ba2a 7ada yejra7ni

W bel ekher betlob mennak talab
R7am el 3elam w r7amni

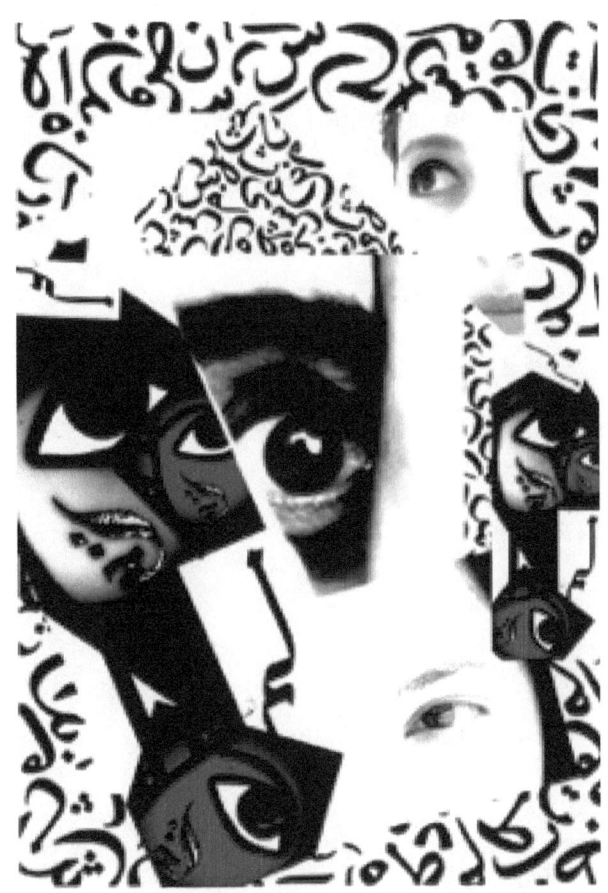

The Me I am by Pamela Chrabieh
Mixed Media and Digital Art, 2016

THE ME I AM

PAMELA CHRABIEH

The Me is a mere stereotype,
An ideological battleground,
A fracture along party lines,
An emotionally-laden symbol of the nation,
A mother who needs protection against the outside enemy,
A *coup d'Etat*.

The me is the background urging,
Praising and supporting.
The Me is a dichotomy,
A binary system,
Purity-impurity,
Honor-dishonor,
A perfect-broken vase,
Bda3a 7elwe-fessde.

The Me is weakness,
Fear, ignorance,
Encroachment,
Conquest, invasion, intrusion…
An internalized oppression.

The Me is permeated by violent imagery,
Thought, emotion and cognition…
A mangled and charred body.

The Me is a percentage, a quota, a commodity, a property…
Exchanged,
Bought and sold in some form or another…
A territory to be conquered, claimed or marked,
Indelibly imprinted.

The Me is a *ghasha2*,
A piece of flesh,
Flesh in pieces,

A plowed land into a gray mass,
An arena of real conflicts and imagined differences.

The Me is a highly erotic entity,
An exotic fantasy,
A complex eulogy,
An object of desire,
A candle around which the lover hovers.

The Me is others' depiction, definition, reality…
A myth,
A threat,
An impending doom.

The Me I Am is a whole different story.
The Me I Am is the quest,
The site,
The integrity I Want and Choose to Be.

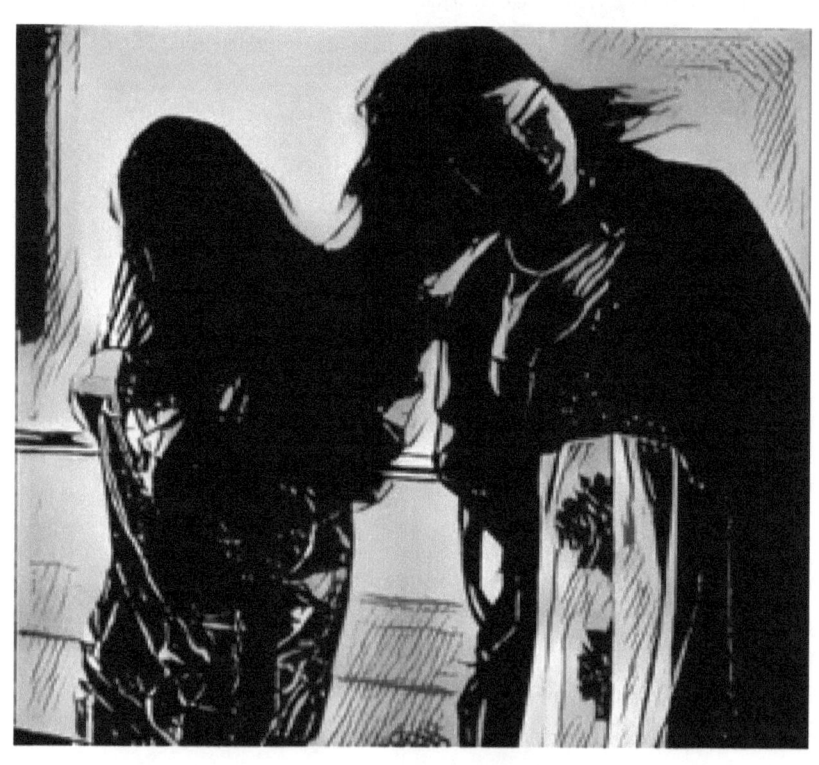

Hurra by Pamela Chrabieh
Photography concept and Mixed Media, 2016

EXPONENTIELLEMENT FEMME

MAYA KHADRA

Il y a trois ans et des poussières, j'insultais encore l'homme oriental. Lui rappelant qu'il est à la base des exactions sociales que subissent les femmes surtout au Moyen-Orient. En ce temps-là, je comprenais mal le féminisme. C'était un moyen pour me venger contre une injustice innée qui suit chaque femme comme une ombre implacable, une expression d'un profond dépit, une volonté pugnace de briser les tabous qui enserrent de leur étau la femme orientale. J'ai nagé à contre courant, usant toute mon énergie à détruire des préjugés, des idées nécrosées, des qu'en-dira-t-on... Personne presque n'a été épargné de mes salves de diatribes.

Ce texte semble bien être une rétrospective faisant office d'une remise en question de toutes mes anciennes publications sur le blog Red Lips High Heels... Ça l'est en quelque sorte. J'esquisse un sourire nostalgique en me rappelant le sobriquet dont j'ai flanqué un cheikh saoudien : Ben Couillon, ou le néologisme « péniculture » qui dénonçait d'une manière caricaturale et très sarcastique l'éducation au machisme dans les pays arabes... Je me souviens de l'invitation adressée aux femmes à ôter leurs soutiens-gorge, l'invitation à l'amour libre, à aller de l'avant, à devenir des femmes entreprenantes et de redoutables battantes. Ces invitations qui passaient souvent pour des exhortations étaient les lignes directrices de ma vie. Je les ai vécues, concrétisées et sanctifiées...

Et aujourd'hui, après la fin de la rage et des orages, après que le sentiment de dépit a cédé sa place à une sérénité faisant de moi une femme dont les cicatrices du passé endurcissent la peau contre les intempéries de la vie, j'abdique tout en luttant davantage. Le paradoxe! Je n'ai plus besoin de calicots haut brandis, de slogans que je scandais dans les rues de Beyrouth à me faire péter les cordes vocales... Les mots violents ont été bannis de mon registre. Féministe ? Non. Plutôt femme. Le suffixe –iste a toujours rimé avec extrémiste, intégriste, etc. C'est le suffixe de l'expression outrancière des idées. Une idée n'a pas besoin d'être attifée d'un suffixe. Le mot, le vrai, n'a pas besoin de condiments morphologiques pour lui

donner du sens. Un mot, une action existent sans médiateurs. Une femme existe sans féminisme et revendique ses droits en tendant sa main à l'homme, aux autres femmes et aux autres cultures... sans hargne, sans inimitiés, sans concurrence... Et mon rêve en cette semaine marquée par la Journée internationale des droits de la femme, est l'entente entre les différents mouvements féministes/de femmes au Liban et dans le Moyen-Orient. Sinon, chaque femme luttera comme un électron libre... Seule, orpheline d'un mouvement qui regroupe la mosaïque riche et panachée des femmes au Moyen-Orient.

Moi, seule en face des vents et des marées de ma nouvelle vie, je me trouve parfois nostalgique de mes luttes sur les réseaux sociaux et ailleurs... Mais je me sens exponentiellement femme, moins en colère, plus pondérée. Et avec ce recul, j'ai compris que je ne suis pas féministe, mais que je veux tout faire pour redorer le blason de la femme orientale, sur tous les plans. Déjà en faisant de mes droits de femme indépendante une valeur sacrée qu'aucune personne ne pourra profaner. Et en écrivant... toujours.

Bonne journée de la femme !

PARCOURS D'UNE FEMME INDEPENDANTE

MAYA KHADRA

Au début, les priorités s'amalgament: Ambition, Amours, Argent, Succès... L'amour concurrence l'ambition et la fige. L'argent se tapit dans l'ombre du succès... Et tout tourbillonne, farandole, et prend son envol irrégulier dans l'espace d'une vie aux contours mal définis.

Passées quelques années qui en valent une dizaine en expériences, une femme indépendante tient fermement la vie dans l'anse de sa main. Les priorités se redistribuent: Famille, Ambition, Amour, Amis... sont sous les feux de la rampe de ce théâtre en tréteau improvisé, provisoirement jusqu'à nouvel ordre. Rien ne passe avant son ambition, rien ne la parasite. L'honnêteté est de mise. Elle n'a pas besoin de prendre des chemins de traverse soupçonneux pour accéder à son but. Tout se fait à la sueur de son front. Son affection redouble pour sa famille et ses ami(e)s. Ces derniers(ères), elle les passe au tamis. Les mauvais(es) qui l'ont leurrée avec leur fidélité artificielle et artificieuse, tirent leur révérence. Les bons(nes) restent et leur présence s'ancrent plus dans son cœur et son quotidien. Ses amours ne conditionnent plus sa vie. Elles sont mises à leur juste place. Elle marche de pied ferme et se surprend par des amours-coquelicots, saisonnières... en attendant l'amour-cèdre qui viendrait ou pas... Elle, elle s'en fiche. Elle n'a plus envie de souffrir pour personne, elle s'en bat des mots fleuris et fleurbleuistes. Et peut très bien s'en passer. Les mots sont le somnifère des immatures. Elle est indulgente avec tous; sauf les générateurs(trices) d'énergie négative... Elle s'en éloigne en toute décence et leur est indifférente. Quand elle trébuche, la chute ne lui fait plus mal comme avant... Sa peau a été rompue aux coups durs. A peine si une larme s'échappe de ses yeux. Puis, elle continue. Rien n'arrête sa marche tant qu'elle ne prend pas la vie au sérieux, tant qu'elle ambitionne rester conséquente avec elle-même et avec les autres.

Après... Elle ne sait pas ce que la vie lui cache dans ses replis périlleux. Elle sait que son mouvement ne s'arrêtera pas, jusqu'à ce que l'huile de sa lampe s'asséchera et qu'elle retrouvera la Force

supérieure qui l'a créée ou le Néant. Elle, encore une fois, elle s'en fiche.

"إشكاليّة" الأدب النسوي

نور زاهي الحسنيّة

إنّ الأدب هو شكل من أشكال التعبير الانساني عن عواطف الانسان وأفكاره وهواجسه بأرقى الأساليب الكتابيّة من شعر ونثر. وحين يرتبط النص الإبداعي بطرح قضيّة المرأة وحريّة المرأة، أو حين يُكتَب بقلم المرأة فإن هذا الابداع يدخل في تصنيف "الأدب النسوي".

تتعدّد دلالات هذا المصطلح، الأمر الذي دفع بالنقاد إلى عدم اجتماعهم على مفهوم نقدي موحّد فمنهم من قال بالنسوية أو الأدب النسوي، ومنهم من وصف إبداع المرأة بكتابة أنثوية، ومنهم من قال بالكتابة النسائية.

ومن الاختلاف على تعريف المصطلح إلى الاختلاف في تأييده أو معارضته بين النقّاد؛ ففي حين يعتبر بعض النقاد أنّ المرأة هي الأجدر على التعبير عن مشاعرها بنفسها وأنّ لكتابتها خصوصيّة معيّنة، يؤكد البعض الآخر أنّ الأدب قيمة إبداعية، لا تعير اهتمامًا لجنس المبدع وأنّ إبداع المرأة هو تجاوبٌ مع موهبتها وليس تكريسٌ لجنسها المختلف عن الرجل.

بدأت كتابة المرأة في الوطن العربي أواخر القرن التاسع عشر وأوائل القرن العشرين ضمن الهيمنة البورجوازية والأرستقراطية ولا سيما المتصلة بالغرب. من ذلك نلاحظ ظهور الصالونات الأدبية لنساء كنّ محط أنظار المجتمع والرجال، على جانب أن الكتابة النسوية ارتبطت بالتماهي السيري من جهة وبكسب التعاطف السائد من جهة أخرى، أي أننا لم نقع على كتابة نسوية متمردة على الأفكار السائدة حتى منتصف القرن العشرين عندما اتسعت مشاركة المرأة في البنيان الاجتماعي والثقافي من خلال انتشار حقوق الإنسان وتنظيمات حرية المرأة، لذلك مع مطلع الخمسينيات نقف على نصوص متمردة لا تتدرج في نفي الذكورة بل في مطالبة المرأة بحقها في الوجود والمشاركة السياسية والاجتماعية، لذلك نشير هنا إلى أن كتابة ليلى بعلبكي وكوليت خوري في أواخر الخمسينيات وأوائل الستينيات كانت متمردة وثائرة، ولكنها أصبحت اليوم أقرب إلى وثائق تاريخية في الحراك الاجتماعي للمرأة، أما الأمر الثالث الواضح في الكتابة النسائية أنه في العقود الثلاثة الأخيرة بدأت الكتابة النسائية العربية تندغم في جوانب منها بمفهوم النسوية الذي ينفي الذكورة بأشكال متعددة ويسير المرأة على

قوانين الحياة بانخداع الجسد في ذلك التعلق بالذكورة.[1]

ولمّا كان مصطلح "النسويّة" قد استعمل لأول مرة في مؤتمر النساء العالمي الأول الذي انعقد بباريس سنة (1892) حيث جرى الاتفاق على اعتبار أنّ النسوية هي" إيمان بالمرأة وتأييد لحقوقها وسيادة نفوذها"[2]، فإن مصطلح "الكتابة النسوية" من المصطلحات النقدية المتشعبة، والتي أفرزت عدّة "إشكاليات عميقة وعليه لابدّ من التفكير في إيجاد مبررات كافية ومقنعة، لتأكيد خصوصية الخطاب الذي تكتبه المرأة"[3]، وقد تعددت الجهود النقدية لتحديد هذا المفهوم وتسييجه بعد ظهور عدّة "صيغ ترادفية أثارت الكثير من الجدل عند ظهورها، لما اكتنف مضمونها من تعميم وغموض"[4]، لكن بقي في الأخير هذا المصطلح هلاميًا متعدد الدلالات، الأمر الذي دفع بالنقاد إلى عدم اجتماعهم على مفهوم نقدي موحّد فمنهم من قال بالنسوية، ومنهم من وصف إبداع المرأة بكتابة أنثوية، ومنهم من قال بالكتابة النسائية.

لقد أسهمت الكتابة الأدبية للمرأة العربية تاريخيًا في تحرير المرأة، وفكرها من استلاب الرجل لحقها في التعبير عن وجودها الإبداعي ونقل مكنونات ذاتها للمتلقي حتى يرى صورتها الحقيقية دون زيف مباشرة دون وسائط مادية أو فكرية تجول بينها وبين المتلقي، فكان لابدّ للمرأة العربية من اتجاهات فكرية تؤسس من خلالها رؤيتها للواقع والذات والعالم الخارجي لكي يتسنى لها نقل فكرها للآخر دون وسائط، وهذه الاتجاهات هي كالآتي:[5]

[1] أمينة عبّاس: بعضهن يرفضن الأدب النسائي، موقع ديوان العرب.

[2] نعيمة هدى المدغري: النقد النسوي (حوار المساواة في الفكر والأدب)، المغرب، منشورات فكر، ط1، 2009م ص18

[3] حفناوي بعلي: النقد النسوي وبلاغة الاختلاف في الثقافة العربية المعاصرة، مجلة الحياة الثقافية، تونس، العدد 195، وزارة الثقافة والمحافظة على التراث، 2008م، ص34.

[4] بوشوشة بن جمعة: الرواية النسائية المغاربية، المغارية للطباعة والنشر والإشهار، تونس، ط1، 2003م، ص15

[5] عامر رضا: الكتابة النسوية العربية من التأسيس إلى إشكالية المصطلح، موقع مجلة اللغة.

أ‌- الاتجاه الأوّل: القائل بمصطلح الأدب النسائي

في مصطلح "أدب نسائي" نجد معنى التخصص الموحي بالحصر والانغلاق في دائرة جنس النساء، وما تكتبه النساء من وجهة نظر النساء سواء أكانت هذه الكتابة عن النساء أم عن الرجال أم عن أي موضوع آخر "فخصوصيات الكتابة النسائية لا تعني وجود تميز مطلق بين الكتابة الذكرية والأنثوية، ويرجع ذلك ليس فقط إلى كون المرأة الكاتبة قد قرأت الكثير من الأعمال الأدبية لكتاب رجال وانطبعت بنماذجهم الثقافية"[6] إن مصطلح الكتابة الأدبية النسائية نجده عند بعض الناقدات، مرادف لتصنيف إبداع المرأة، وهذا حسب تعبير رشيدة بنمسعود[7]، وعليه فالأدب النسائي لايعني بالضرورة أنّ المرأة كتبته، بل يعني صراحة أنّ موضوعه نسائي، إذن "التجربة دائمًا متغيرة حسب الزمان والمكان والطبقة والخلفية الثقافية والجنس والخبرات الجانبية ولا يمكننا تجاهل هذه العوامل لنضع مجموعة أعمال في سلة واحدة ونطلق عليها "أدب نسائي" وإلّا سقطنا في المطلق مرة أخرى وشبكة الصور النمطية"[8].

ب- الاتجاه الثّاني: القائل بمصطلح الأدب الأنثويّ

إنّ لفظ الأنثى يستدعي على الفور وظيفتها الجنسية، وذلك لفرط ما استخدم اللفظ لوصف الضعف والرقة والاستسلام والسلبية، حيث أنّ مصطلح "أنثويّ" محمول على معجم اصطلاحي يحيل على عوالم الأنثى المحمولة على الضعف والاستلاب والرغبة، ولا يمكن بأيَ حال من الأحوال أن يكون من أسس تصنيف النص في خانة تدلّ على أنّ النص نسويّ- أي نصًا مكتوبًا بقلم المرأة - إذ يمكن للرجل أن يكتب نصًا أنثويًا، ودليلنا على ذلك "شعر نزار قبّاني" الذي لا يمكن تسميته بالنص النسوي استنادًا لمرتكزات النوع، وعليه تقترح الناقدة " زهرة

[6] نعيمة هدى المدغري: النقد النسوي (حوار المساواة في الفكر والأدب)، المغرب، منشورات فكر، ط1، 2009م، ص98.

[7] رشيدة بن مسعود: مبدعة، وناقدة وباحثة مغربية، لها كتاب نقدي المرأة والكتابة، سؤال الخصوصية، بلاغة الاختلاف، وجمالية السرد النسائي إلى جانب مقالات نقدية منشورة في دوريات

[8] شرين أبو النجا: عاطفة الاختلاف (قراءة في كتابة نسوية)، الهيئة المصرية العامة للكتاب، مصر، ط1، 1998م، ص46.

الجلاصي"[9]: استخدام مصطلح "النصّ الأنثويّ" بديلًا عن مصطلح "الكتابة النسوية" مؤكدة على التعارض القائم بين المصطلحين من حيث الدلالة والمعنى المعجمي، إذ نجده يشير إلى "نوع من الكتابة النقدية النسائية، التي نبعت من نسوية الناقدات الفرنسيات المعاصرات"[10]، واللواتي يبحثن لأنفسهن عن التأسيس الفعلي.

"مفهوم الأنوثة بشكل عام هو تركيب ثقافي، لأنّ المرأة كما تقول سيمون دوبوفوار [11]: لا تولد امرأة، بل تصبح كذلك حيث يعمد المجتمع الأبوي، استنادًا على وجهة النظر هذه، إلى فرض مقاييس اجتماعية عن الأنوثة، على جميع النساء"[12]. في حين ترفض بعض الناقدات الخلط الاصطلاحي" وتحاولن إثبات أنّ النساء وإن كنّ إناثًا بلا شك فإن هذا لا يضمن بالضرورة أنوثتهنّ كمفهوم ثقافي، كما لا يضمن نسويتهنّ كمفهوم سياسي"[13]، بشكل مطلق.

جـ ـ الاتجاه الثالث: القائل بمصطلح الأدب النسويّ

أمّا مصطلح "النص النسويّ" فيات الأكثر دلالة إلى حدّ كبير على خصوصية ما تكتبه المرأة في مقابل ما يكتبه الرجل، فالنسوية إذن تمثل وجهة نظر النساء بشأن قضايا المرأة وكتابتها، وما تحمله من "خصوصيات تجعل منه ظاهرة مميّزة وعلامة دالة في حق الإبداع الأدبي"[14]، إذن فلابدّ للأدب النسوي أن يحمل صفة النسوية التي تتحدد بحسب آراء الدارسين من خلال نوعية اللغة الموظفة داخل العمل

[9] زهرة الجلاصي: باحثة جامعيّة من تونس

[10] سارة جامبل: النسوية وما بعد النسوية (دراسات ومعجم أدبي)، ترجمة أحمد الشامي، المجلس الأعلى للثقافة، مصر، 2002، ص.223.

[11] سيمون دوبوفوار: كاتبة ومفكرة فرنسية، وفيلسوفة وجودية، وناشطة سياسية، ونسوية.

[12] نعيمة هدى المذكري، النقد النسوي (حوار المساواة في الفكر والأدب)، المغرب، منشورات فكر، ط1، 2009م، ص.19

[13] ن. ص.19، 20.

[14] بوشوشة بن جمعة: الرواية النسائية المغاربية، المغارية للطباعة والنشر والإشهار، تونس، ط1، 2003م، ص.16

الإبداعي، فالنسوية "لا تقتصر على كونها مجرد خطاب يلتزم بالنضال ضد التمييز الجنسي ويسعى إلى تحقيق المساواة بين الجنسين، وإنما هي أيضا فكر يعمد إلى دراسة تاريخ المرأة وإلى تأكيد حقها في الاختلاف، وإبراز صوتها وخصوصياته"[15]، أي أن هناك لغة أنثوية تكون خاصة بالكاتبات دون سواها من المبدعين، فضلًا عن التجربة الإبداعية والخصوصية النسوية التي تميّزها عن سواها، فهي الأقدر في تصوير مختلف جوانب تجربتها الخاصة، وما تخفيه من مكنونات، ورغبات وآهات، وهذا الرأي قد استأنست إليه الكثير من المبدعات، لكن مع وجود خصوصيات على مستوى الفكر لا يستطيع أن ينكرها أيّ شخص.

- المؤيدون:

الفريق المتبنّي لمصطلح الكتابة النسائية، والقائل بوجود خصوصيات في هذه الكتابة تُميّزها عما كتبه الرجل، ومن مُتبنّي هذه الفكرة نجد العديد من النقّاد من جملتهم:

زهرة الجلاصي، التي أكّدت أنّ للمرأة حقًا في الكتابة والتميّز، فقد أعطيت حقوقًا كثيرة، و"لعلّ من أهمّ الحقوق التي كسبتها المرأة حق امتلاك شهادة ميلاد كاتبة، تُخوّل لها الخروج من دائرة المجموعة الصامتة، لتُصبح مقروءةً ومسموعة، ولتتخذ لها مكانًا في المشهد الأدبي، وهي اليوم أشدّ وعيًا من أيّ زمن مضى بدورها كمُنتِجةِ خطابٍ يبلغ صوتها ويُساهم في توصيل مواقفها ووجهات نظرها، سواء فيما يخصّ صورتها أو علاقتها بالمُجتمع، فهي تُدرك دور أشكال التمثيل الأدبي (شعر، قصة، ورواية) في تغيير السائد، والانتصار على رواسب "ثقافة الموؤودة"؛ من أجل تكريس "ثقافة المولودة"[16]، من هنا يتّضح بأن حصول المرأة على هذه الشهادة لم يكن من الأمور السهلة، بل كابدت وعانت لتجعلَ لنفسِها قيمةً داخلَ الساحة الأدبية العربية.

والغريب في الأمر أن العديد من الناس يَعتبرون كتابة المرأة ظاهرةً جديدةً،

[15] نعيمة هدى المدغري: النقد النسوي (حوار المساواة في الفكر والأدب). المغرب، منشورات فكر، ط1، 2009م، ص18.

[16] زهرة الجلاصي: ما بعد الكتابة النسائية. تونس، مجلة آفاق، العدد 67، 2002م، ص34.

في حين ترى الباحثة رشيدة بنمسعود أن هذه الخصوصية كانت موجودة منذ القِدم فـ"الكتابة النسائية باعتبارها نشاطًا إبداعيًا هي موجودة فعلاً منذ الخنساء حتى حنان الشيخ وسحر خليفة؛ لأن كل ما تَكتُبه المرأة - حسب فرجينيا وولف17 - هو دائمًا نسائيٌ، والكتابة الصادرة عن المرأة كما هو معروف تُعتبَر كتابة فنة كانت تعيش على الهامش، لكنها اليوم نراها تزحَف بإصرار وصمتٍ نحو مركز الفعل الثقافي والسياسي، فمِن خلال مُقاربتنا لبعض الإصدارات النسائية خاصة على مستوى السرد، القصة / الرواية، وانطلاقًا من بعض المكونات السردية التي تتمثل في (الشخوص- اللغة - التيمة) نلاحظ أن السمات العامة التي تتميَّز بها الكتابة النسائية تتحدَّد أساسًا في الحضور المُرتفِع للمرأة، البطلة. فهذا الحضور برأيها يكشف عن الموقع الاجتماعي الذي تحتله المرأة داخل الهرم المُجتمعي، وبهذا ترتبط الكتابة النسائية بما هو مرحلي، الشرط الاجتماعي بوجوهه المتعدِّدة: القهر، الاضطهاد، والدونية، لكن هذا الوضع الذي تُعاني منه المرأة والذي يَنعكِس بدوره على كتاباتها له علاقة بمُواصفات تاريخيَّة وثقافية وسياسية قد تؤول إلى الزَوال إذا غابت شروطها الموضوعية، وهذا ما يجعل من الموقع الاجتماعي تعبيرًا عن لحظة في مسار الكتابة النسائية وليس شرطًا محدِّدًا لها"، فهي تُميِّز الكتابة النسائية في موضوعها، وليس في جنسها، وهو ما تسعى إليه الجهود النسائية برفض التمايز على أساس جنسي، بل موضوعي أو أسلوبي. مِن هنا نستشفُ أن التمايز ليس حبيس الاختلاف الجنسي، بل طريقة الكِتابة، ومُعالجة المواضيع هي مقياس التمايُز عند الكاتبة، التي تُعتمد لغتها الخاصة، إلى جانب الرجل.18

ومن ناحيته، أشار الدكتور حامد أبو أحمد ناقد19 إلى وجود ما يسمى بالأدب النسائي وخصوصًا في الغرب، وعرفه بأنه، أدب احتجاج ضد سيطرة الرجل، وأوضح أن هناك ثلاثة أنواع من الأدب الذي تُنتجه المرأة أحيانًا، أولًا الأدب الذي تنتجه من أجل أن تشارك في إنتاج أدب إنساني، دون أن تشغل نفسها بالصراعات الجنسية، و تأثيراتها السلبية على نتاجها، و ثانيًا الأدب الذي تحاربها به الرجل، و العقلية التي تعمل على

17 فرجينيا وولف: أديبة إنجليزية، اشتهرت برواياتها التي تمتاز بإيقاظ الضمير الإنساني

18 صفاء درويش: إشكالية الكتابة النسائية بين القبول والرفض، موقع شبكة الألوكة.

19 حامد أبو أحمد: ناقد مصري وعميد كلية اللغات والترجمة الأسبق في مصر.

ترسيخ فكرة تهميش، و تجاهل النتاج الأدبي النسوي، و ثالثًا الأدب الذي تخدم به جنسها، و تعزل من خلاله نفسها عن العملية الإنسانية الكبرى، و الذي يعود عليها بالسلب غالبًا أكثر مما يعود عليها بالإيجاب، مؤكدًا على أن مبتدع فكرة أو مصطلح الأدب النسوي، الرجل وليس المرأة، الذى لا يؤمن أصلًا بإبداع المرأة.

وقال : إذا نظرنا للأدب النسائي، على أنه أدب احتجاج ضد سيطرة الرجل، نستطيع القول إذن، أن هناك ما يسمى بالأدب النسائي، لأن هناك قضية ستظل قائمة، و هي دفاع المرأة عن حقوقها ضد هيمنة الرجل، وسيطرته، و إذا نظرنا لوجهة نظر الكاتبات في هذا الموضوع، نجد الكثير منهن يرفضن هذا المصطلح، لأنهن يرين أنه إذا كانت المرأة في المجتمع الشرقي مقهورة، فالرجل مقهور أكثر منها، وبالتالي هي تدافع عن الرجل، مثلما تدافع عن نفسها، لأن القهر، يشمل الجنسين، فهناك القهر الاجتماعي، والاقتصادي، والسياسي، الذي يجعل المرأة والرجل، فى صف واحد، وإذا كان القهر قد انتهى في المجتمعات الغربية ـ كما يظن البعض ـ، فالمرأة مازالت ترى أن لها مصالح لم تحصل عليها بعد، ولذا فهذا المصطلح منتشر جدًا عند الغرب، بل الأدب النسائي في الغرب، هو اتجاه قائم بذاته.

وتابع : أنا كناقد أعتبر المرأة في حالة كفاح لإخراج المجتمع من حالة التخلف، والجهل، والهيمنة، والديكتاتورية، والقضية الآن، ليست قضية رجل، وامرأة، وإنما قضية الدفاع عن مجتمع مهمش من قبل جهات معينة، فالقهر واقع على الجنسين، بل على كل فئات المجتمع.[20]

أما الكاتبة رشا سمير[21] فتعتبر أن المرأة هي الأجدر على التعبير عن مشاعرها بنفسها، لاسيما مع الصورة السيئة أو النفعية التي يصورها بها الأدب الذكوري. وتستطرد قائلةً: "الأدب شيء رائع وقيّم، ووجود عدد من الحركات النسوية في المجتمع يعد مجالًا لتعبير المرأة عن نفسها، فبلا شك أن الكاتبات يفرغن شحناتهن و تجاربهن على الورق، حتى دون أن يدرين، فخبرة الكاتبة هي التي تتحكم في إنتاجها الأدبي"، وتضيف قائلةً: "عن تجربتي الشخصية أجد أنني في كثير من الأحيان أكتب ما مررت به أو شعرت به، وهذا كان تعليق أستاذي جمال الغيطاني عن روايتي "بنات

[20] رشا أحمد: الأدب النسائي إشكالية المصطلح وواقعية المعالجة، موقع رسالة الإسلام.

[21] رشا سمير: روائية وكاتبة صحفية مصرية.

في حكايات"، والتي لا أنكر وجود بعض الجوانب من مشاعري وأفكاري بها"[22].

- **المعارضون:**

"الواقع أن التصورات النقدية التي حاولت الاقتراب من إشكالية "الأدب النسائي" قصد معالجتها واستخلاص ما قد تتوفر عليه من سمات مفيدة وكذلك المنظورات الإبداعية التي أنتجت هذا اللّون من الأدب تنزع إلى رفض هذا المصطلح الذي يُجزئ فعل الإبداع، وإن كانت تقرّ في سياق رفضها ما يتوفّر عليه هذا النمط من الكتابة التي تنشئها المرأة من خصوصيات تجعل منه ظاهرة مميّزة وعلامة دالة في حقل الإبداع الأدبي"[23] في مختلف توجهاته.[24]

وقد عبرت بعض الكاتبات عن رفضهن لهذه التسمية على اعتبار أن هذه التسمية غير دقيقة فكيف من الممكن إطلاق مصطلح "الأدب النسوي" وليس من الشائع إطلاق تسمية "الفن التشكيلي النسوي" مثلا، أو "الموسيقى النسوية"، لكنهن مع رفضهن الاعتراف بمثل هذه التسمية، إلا أنهن اعترفن بوجود كتابات أنثوية تقابلها كتابات ذكورية، لا تتعلق بقضية رجل أو امرأة بقدر ما هي نسبة الأنثوية التي يحتويها النص سواء كان الكاتب رجلًا أو امرأة، ونسبة الذكورية التي يحتويها أيضًا بغض النظر عن جنس كاتبه.

أما الخصوصية التي تكتب بها المرأة نصوصها المختلفة كما ذكرت بعض الكاتبات، والروح المتفردة التي تظهر في نصوص المرأة، وعنايتها بالتفاصيل الدقيقة فيمكن إدراجها جميعًا تحت باب الفروق بين كتابة الجنسين، إذ تحفل أيضا كتابة الرجل بخصوصية وتفاصيل وسمات خاصة.[25]

[22] أمينة عادل: الأدب النسوي إشكالية المصطلح وهموم المبدعات، موقع البيان.

[23] بوشوشة بن جمعة: الرواية النسائية المغاربية، المغارية للطباعة والنشر والإشهار، تونس، ط1، 2003م، ص15-16.

[24] عامر رضا: الكتابة النسوية العربية من التأنيس إلى إشكالية المصطلح، موقع مجلة اللغة.

[25] "الأنثوية في الأدب" إشكالية المصطلح وتحليل نصوص إبداعية، موقع ميدل إيست أونلاين.

ورغم خصوصيات الكتابة النسائية فلقد بقي مصطلح "الأدب النسوي" مرفوضًا وغير مستساغًا لدى الكثير من الباحثات والباحثين ومنهم:

عبد العالي بوطيب[26] الذي يرفض هذا المصطلح انطلاقًا من فكرة أن "الأدب واحد، لا يقبل التصنيف بناءً على معايير خارجية غريبة كليًّا عن كينونته، ويوضّح أن المرأة عندما كتبت لم تُمارس الإبداع ليوصَف بالنسائية، وإنما أبدعت تجاوبًا مع موهبتها التي صقلتها بالتعليم والممارسة والتجربة الإبداعية، ولتُصوّر واقعَها بمنظارها الخاص؛ لا أن تكون منظارًا فقط يُنظر من خلاله، ولعل تصريحات المبدعات خير دليل على ذلك، ومن جملتهن: نبيلة إبراهيم[27] التي تجيز استخدام هذا المصطلح شريطة ألا يكون هذا حكمًا مسبقًا بأنّ ما يكتبه الرجل أرقى مما تكتُبه المرأة؛ لأن الأدب تعبير عن القضايا الإنسانية والاجتماعيّة، والهموم الذاتية، ولا يَرتبط بجنس كاتب أو بطبيعة.[28]

"إن المرأة كانت ولا تزال كائنًا بشريًّا مُفكّرًا وموجودا بتعليمه وفكره، لذا فمن حقها التعلم والعمل والإبداع دون أن توضَع أمامَها عراقيل وإشكالات مزيّفة تُعسّرها عن بلوغ سيرها، أو تحدّ من غزارة إبداعها، فهي والرجل يشتركان في صفة "إنسان"، وهذا الأخير " ذو إبداعات خلاقة ومُجددة، فلا يمكن أن تأتي جميع الإبداعات مُتشابهة أو مُكررة، فلا بدّ من التجديد والتلوين والتغيير حسب ثقافة كل مبدع وبيئته وظروفه"[29]، هي الفكرة التي انطلقت منها كل مبدعة للخلق، والتي تُناضل من أجلها بغية حذف تلك التسميات التي لا أهمية لها، مع العلم أن الكاتبات لسن الوحيدات، ولكن أيّدهُنّ في الرفض بعضُ النقاد؛ منهم عبد النور إدريس[30] قائلاً: "إن مسألة الإبداع لا تخضع للتصنيف الجنسي، فكتابة الرجل هنا لا يمكن أن نضعها مقياسًا للكتابة المُحتداة، وإلا أصبحنا نقيس كتابة المرأة كهامش بالنسبة لمركزية الرجل، فعندما تحصل المرأة على نفس الحُظوظ في المشاركة،

[26] عبد العالي بو طيب: أستاذ جامعي من المغرب، يكتب في النقد الروائي العربي والسرد بشكل عام.

[27] نبيلة إبراهيم: ناقدة مصريّة وأستاذة الأدب الشعبي في جامعة القاهرة.

[28] فاطمة طحطح: مفهوم الكتابة النسائية (بين التبني والرفض)، الأنثى والكتابة، أفروديت ص533.

[29] رشيدة بنمسعود: الكتابة النسائية بحثًا في إطار مفهومين، مبادرة نسائية، دار الفنك، ص144.

[30] عبد النور إدريس: أديب وباحث من المغرب.

في الحياة العامة وفي الإنتاج الفكري والمجال الحقوقي سيصعب على الناقد الاحتفاظ بتمييز واضح بين كتابة المرأة وكتابة الرجل"[31].

ومن الأقلام التي عبّرت عن الكتابة النسائية نذكر الشاعر عبدالواحد معروفي[32] الذي عرّفها بـ"كلّ ما تكتبه وتُبدعه في عالم الفكر والثقافة والأدب هو أدب أنثوي، وإن تعدّدت الأسماء والصفات، هذا المُصطلح هو ضيّق الرؤيا، ضيق التعبير، لا ينهض على أسس صحيحة، ولا يُثبت صحّته للمفهوم الذي يرمز إليه.

كما بيّن عبدالواحد معروفي أن أدب المرأة هو كل ما تبدعه في مجال الأدب والثقافة معترضًا على التسمية؛ لأنه يرى فيها تضييقًا للمعنى؛ ففعل الكتابة عنده أكبر من أن يُحدّ بمصطلح، فالمفروض أن يحظى الأدب بالدراسة لا المصطلح، فهو يعتبره إبداعًا له أهدافه دون الرجوع إلى جنبيه مؤكدًا ذلك بقوله:"الأدب هو أدب المجتمع الذي ينبثق منه أدب الأمّة التي يعيش فيها ويستوحي من واقعها أدب العقول المُنتجة، والأفكار المدبّرة، وبالتالي فهو أدب نسائي بغضّ النظر عن جنسه ذكرًا كان أو أنثى، وما يشترط في الأدب هو الجودة والفائدة والتبليغ والتأثير والواقعية، وهذا ما يدفعنا إلى الفصل بين الأدب الرجالي والأدب النسائي، ولا ينفي صفة الإبداع أو الكتابة عن أحد الجنسين؛ لأن الذي يجب معرفته هو أنّ للمرأة تصوّرًا مُختلفًا عن الرجل في كلّ لحظة وفي كلّ شيء، وهذا لا يعني أنّها أقل منه، بل يُثبت لها جرأتها في الموقف، فالعديد من النقاد يرون في الأدب أدبًا لا يعتمد على التصنيفات الجنسية"[33].

وتؤكد القاصّة لبنى ياسين[34] على ضرورة تحديد معيار التصنيف، فتشير أنّه من ناحية الإبداع لا تجد فرقًا في الكتابة معياره الجنس بل الاختلاف هنا شخصي تمامًا، أما من ناحية الأسلوب فقد تكون المرأة أشد حياة في معالجة أمور العاطفة والجنس وأكثر شفافية ورقّة في التعبير عن

[31] عبد النور إدريس: المرأة والكتابة والجسد، دلالة الجسد الأنثى في السرد النسائي العربي، مطبعة سجلماسة، مكناس، 2006م، ص11.

[32] عبد الواحد معروفي: شاعر من المغرب.

[33] صفاء درويش: إشكالية الكتابة النسائية بين القبول والرفض، موقع شبكة الألوكة.

[34] لبنى ياسين: كاتبة صحفية وروائية وفنانة تشكيلية سوريّة.

المشاعر التي تنتابها أو تنتاب أبطال قصصها مثلًا من نظيرها الكاتب الرجل وبالطبع ستسيطر عليها خصائص شخصية المرأة وخاصة إن كنا نتحدث عن المرأة الشرقية، ففي الغزل مثلًا...قصيدة حب لامرأة تغازل فيها حبيبها تختلف تمامًا عما يكتبه رجل لحبيبته، فمثلا قد نجد الكثير من القصائد أو القصص النسائية التي تحمل معنى (متى سيشعر هذا الرجل بمشاعري ويدنو ويبوح لي بمشاعره) ولكن لن نجد مثل هذا الموضوع عند الرجال لأنه هو المعني بالبوح و المصارحة وهذا فارق في شخصية المرأة والرجل أساسًا، نحن لا نخلع شخصيتنا جانبا أثناء الكتابة مهما حاولنا أن نكون حياديين، هناك شيء منا يتسلل خفية بين السطور لكن القارئ يلاحظه بوضوح لذا قد نجد هذا الفارق في تناول موضوع الحب والعواطف وما إلى ذلك.

أما في الهموم الوطنية والإنسانية فلن نستطيع على الأغلب أن نفرّق بين كتابة امرأة ورجل لأنها هموم إنسانية وهما أمامها سواء تمامًا لا فرق بينهما.

وتشير ياسين أنّ تعبير أدب نسائي قد يُطرح كمعيار تصنيفي كما نقول أدب المهجر مثلًا المقصود هنا دراسة آثار النساء الأدبية وخصوصية طرحهن ورؤيتهن للقضايا المطروحة وقلة تواجدهن العددي على الساحة مقارنة بتواجد الرجل، وطالما أن المعيار لهذا التصنيف ليس بقصد الإقلال من شأن المرأة بل بقصد إظهار خصوصيتها واختلاف رؤيتها فلا مشكلة لديها بقبوله والترحيب به أيضًا.[35]

من جهتها تعترف الروائيّة التونسيّة آمال مختار بوجود كتابة أنثويّة وأخرى ذكوريّة وتعتبر أنّ هذا التصنيف ليس مرتبطًا بجنس الكاتب بقدر ما هو مرتبط بدرجة الأنوثة والذكورة الموجودة داخل كل إنسان، إذ هناك كتابة ذكوريّة عند نساء كتبن الأدب وهناك كتابة أنثويّة عند رجال كتبوا الأدب.

"الحكاية ليست حكاية نساء ورجال بقدر ما هي حكاية ذكورة وأنوثة وهذا بديهي لأنّه قانون الطبيعة التي وضعت هذا التجنيس لتتكامل الأشياء. فالنص الأنثوي -بغض النظر عمّن كتبه- نص ينبض بالتأكيد بعالم الأنثى

[35] إيمان عباس: بعضهن يرفضن الأدب النسائي، موقع ديوان العرب.

الثري بأحاسيسها وتجاربها وتفاصيلها وذكائها العاطفي الذي لا يتوفر عند الذكر الذي يختلف ذكاؤه وعالمه ومشاعره وتجاربه ورؤيته للحياة".[36]

في النهاية نصل إلى أنّ إشكالية مصطلح "الأدب النسوي" تبقى مسألة متعددة الأوجه، والأطراف خاصة في ظلّ رفضه من طرف العديد من النساء المبدعات لما وجدن فيه من خطورة في تصنيف كلّ ما تكتبه المرأة تحت اسم "الأدب النسوي"، فقد يكرّس الهيمنة النسوية تحت مظلة الإبداع الأدبي ممّا يخلق لنا نوعًا من التقسيم والكراهية الأدبية على مستوى الجنس، فيخرج بذلك عن معيار الإنسانية التي تبحث عن التكامل الفكري والأدبي.

ومن الملفت أنه حتى في داخل صفوف المعترضين على المصطلح، هناك تباين في أسباب الاعتراض، فالبعض يعترض انطلاقًا من أن الأدب واضح لا يقبل التصنيف بناءً على معايير خارجيّة تتعلق بجنس صاحبه، والبعض الآخر يرفض هذا المصطلح لأنه لا يمكن أن نضع كتابة الرجل مقياسًا للكتابة المُحتذاة، وهناك من يجد الاختلاف في الكتابة شخصيًا فلا فرق بين كتابة رجل أو امرأة معياره الجنس.

ليتبين لنا في الأخير عمق الإشكالية من جهة، وخطورة استخدام مصطلح "الأدب النسوي" لما فيه من سعة الدلالة وعمق التأويل، والذاتية في الطرح.

[36] أوس داوود يعقوب: شاعرات وروائيات عربيات يحاكمن مصطلح "الأدب النسوي"

- **الكتب:**
- أبو النجاء، شيرين: عاطفة الاختلاف (قراءة في كتابات نسوية)، الهيئة المصرية العامة للكتاب، مصر، ط1، 1998م.
- إدريس، عبد النور: المرأة والكتابة والجسد، دلالة الجسد الأنثوي في السرد النسائي العربي، مطبعة سيلماسة، مكناس، 2006م، ص11.
- بن جمعة، بوشوشة: الرواية النسائية المغاربية، المغارية للطباعة والنشر والإشهار، تونس، ط1، 2003م.
- بنمسعود، رشيدة: الكتابة النسائية: بحثًا عن إطار مفهومي/ مساهمة في كتاب جماعي: مبادرات نسائية، دار الفنك.
- جامبل، سارة: النسوية و ما بعد النسوية (دراسات ومعجم أدبي)، ترجمة أحمد الشامي، المجلس الأعلى للثقافة، مصر، 2002م، ص223.
- المدغري، نعيمة هدى: النقد النسوي (حوار المساواة في الفكر والأدب). المغرب، منشورات فكر، ط1، 2009م، 253 ص.

- **المجلات:**
- بعلي، حفناوي: النقد النسوي وبلاغة الاختلاف في الثقافة العربية المعاصرة، مجلة الحياة الثقافية، تونس، العدد 195، وزارة الثقافة والمحافظة على التراث، 2008م.
- الجلاصي، زهرة: ما بعد الكتابة النسائية. تونس، مجلة آفاق، العدد 67، 2002م، ص.34.
- طحطح، فاطمة: مفهوم الكتابة النسائية (بين التبني والرفض)، الأنثى والكتابة، مجلة أفروديت، ص533.

- **المراجع الإلكترونية:**
- أحمد، رشا: الأدب النسائي إشكالية المصطلح وواقعية المعالجة (30-4-2009) من //:http woman.islammessage.com/article.aspx?id=3129
- الأنثوية في الأدب: إشكالية المصطلح وتحليل نصوص إبداعية (8-11-2015) من //:http www.middle-east-online.com/?id=210975
- درويش، صفاء: إشكالية الكتابة النسائية بين القبول والرفض (25-2-2016) من //:http www.alukah.net/literature_language/0/99487/#ixzz4SLzdhRPg
- رضا، عامر: الكتابة النسوية العربية من التأسيس إلى إشكالية المصطلح (1-4-2016) من http://www.allugah.com/post.php?id=21
- عادل، أمينة: النسوي إشكالية المصطلح وهموم المبدعات (10-7-2014) من //:http www.albayan.ae/books/library-visit/2014-07-11-1.2161881
- عباس، إيمان: بعضهن يرفضن الأدب النسائي (24-3-2006) //:http www.diwanalarab.com/spip.php?page=article&id_article=3816
- يعقوب، أوس داوود: شاعرات وروائيات عربيات يحاكمن مصطلح "الأدب النسوي" (9-12-2013) من http://alarab.co.uk/?id=10185

Al Salamu Alaykum by Pamela Chrabieh
Mixed Media on Canvas, 2016

A LITTE EMPATHY WOULD GO A LONG WAY

PAMELA CHRABIEH

I attended a Dubai Slam Poetry session in spring 2016 and one of the talented young poets, Syrian Sarah Tamimi, told the story of war through a daughter's promise to her departed mother: 'Don't look back'... What I understood from Sarah's tearful performance which content evoked my own experience in Lebanon's physical war zone in the 1980s, is not the importance of letting go of the past, but of not letting the pain of the past steal the blessings of today and the promise of tomorrow. Palestinian-Canadian Dr. Nadia Wardeh and I had a serious conversation following the session about the power of memory and the importance of cultural resistance, and how we were both moved by Sarah's words. 'Empathy' (*al ta'atuf*) came to my mind.

Empathy is usually defined as the ability to sense other people's emotions (affective empathy) and to imagine what someone else might be thinking or feeling (cognitive empathy). Empathetic individuals are more likely to help others in need, even when doing so cuts against their self-interest. Empathy definitely fights inequality, reduces prejudice and racism, encourages people to reach out and help others who are not necessarily in their social group, and boosts positive human relations. Empathy is good for the office – managers who demonstrate empathy have better performing employees who also report greater happiness. It is good for professionals in education, health and social care. Some scholars argue that there is a genetic basis to empathy, while others suggest that people can enhance or restrict their natural empathic abilities. Empathy is therefore a culture in itself that is – or not – nurtured. Many religious and philosophical traditions have favored empathy as key to moral thought, conduct, or motivation. However, being religious does not guarantee being empathetic.

Following up on our conversation the next morning, I wondered about the flood story in the Bible, and the numerous interpretations found in Jewish and Christian traditions. Contrary to Noah's portrayal in the 2014 American biblical epic film directed by Darren Aronofsky, a figure with different characteristics is depicted in the sacred scriptures, the figure of an absentee from the moment God

speaks to him until he leaves the ark and steps on to dry land. Noah expresses no shock or horror at the idea of the mass destruction, nor does he plead with God to think again. Was Noah's silence the sign of lack of empathy? But the story continues with Noah having to feed the animals in the ark for an entire year without sleep. Noah learns how to know and care for others. According to Scottish Torah scholar Dr. Avivah Gottlieb, "the ark becomes a crucible in which a new type of sensibility is nurtured. The ark is to be a laboratory of kindness" (*The Genesis of Desire*). Zomberg finds a drama about 'civilizations' in the flood story: the real crisis of human beings is that "they have become so open that they are closed to one another".

Zomberg's theory reminds me of Samuel Huntington's – *The Clash of Civilizations*. For Huntington, the more the 'Western' and 'Islamic' civilizations are open to one another, the more they will realize their differences thus will clash. Openness definitely carries with it the risk of conflict, but it paves the way for making the unfamiliar familiar, for mutual respect, dialogue and conviviality. Empathy requires openness but it should be coupled with paying attention. Psychiatrist Ronald David Laing explains the dilemma facing many individuals who are not able to develop empathy because they fail to notice others: "*The range of what we think and do is limited by what we fail to notice. And because we fail to notice that we fail to notice, there is little we can do to change; until we notice how failing to notice shapes our thoughts and deeds.*" In simpler words, to have empathy, I have to be able to see. To have empathy for you, I have to be able to see you.

I saw Sarah, and I could see in her poem the daughter running and her mother screaming: 'Don't look back!' I saw refugees in camps and in the streets of Beirut. I saw friends and family members die because of the war in Lebanon, in Syria, Palestine and Iraq. Is seeing/noticing the key? We are bombarded with scenes of suffering and horrible deaths night and day on all media channels. Does this continuous reminder contribute to a culture of empathy or does it push individuals to eliminate the more humane elements in them as a means of protection, of survival? Seeing/noticing could also block one's empathy and therefore create an affective social distance. Seeing too much could provoke fatigue – 'empathy fatigue' -, a sense of lack of power to affect change when we are faced with unrelenting bad news.

To have empathy for you, I have to become more mindful of what I see/notice, I have to learn to *feel with* and *feel into*, and not be afraid of *feeling beyond* my local narrow borders, beyond my comfort zone. I have to learn to understand. I have to learn to beat the 'empathy fatigue'. Seeing Sarah and the Syrian war through Sarah's words, feeling Sarah and her characters' pain, merging our emotions, and understanding Sarah and refugees who lost their loved ones, their homes, their past, and are hanging on the thin strings of life in order not to lose their future. As Albert Einstein explains it in *Mathematical Circles:* "A human being is a part of the whole, called by us "Universe," a part limited in time and space. He experiences himself, his thoughts and feelings as something separated from the rest, a kind of optical delusion of his consciousness. This delusion is a kind of prison for us, restricting us to our personal desires and to affection for a few persons nearest to us. Our task must be to free ourselves from this prison by widening our circle of compassion to embrace all living creatures and the whole of nature in its beauty. Nobody is able to achieve this completely, but the striving for such achievement is in itself a part of the liberation and a foundation for inner security".

Truly, a little empathy would go a long way.

MEET THE AUTHORS

HAELEY AHN

What are your primary sources of inspiration?

I have always loved words — I tend to be inspired more by not events themselves, but what others make of those events. I collect quotes from novels and poetry, and these days I've begun to explore Korean writing as well. My favourite quote as of now is:

"There are chords in the hearts of the most reckless which cannot be touched without emotion." Edgar Allen Poe, "The Masque of the Red Death"

A friend I met at a summer program two years ago also introduced me to the beauty of the spoken word, and I love to surf around YouTube for these poets also.

Whenever I read or hear anything that resonates with me, I record them in my A4 diary, so that I can always look back and feel the same emotions a week, month, or year later. It's strange and exhilarating that a sequence of vowels and consonants, stutters and sighs, pauses and slurs, is enough to bring back so many memories. It is because of this personal significance of record-keeping, that I decided to handwrite my piece for this book — just like I would have written it in my diary.

How has your personal background influenced your art?

I've had the privilege of receiving an international education in various areas of the world, surrounded by inspiring peers and teachers who have taught me the value of social tolerance and equality. In this way I am a typical 21st century "third-culture kid," who grew up in a liberal atmosphere that sharply contrasts the beliefs that pervaded my parents' generation. I hearken to the ideals that I have developed from meeting the many different people that inhabit this world.

But at the same time, I attended middle school in Korea, which were very formative years; I identify myself solely with the Korean

heritage, and naturally I am very invested in the social movements of my home country. It is a little painful to acknowledge that Korea is far too socially conservative in general to my liking as of now. But it is impossible for me to produce any form of expression without considering Korea.

NOUR ZAHI AL-HASSANIEH

Nour Al-Hassanieh is a Lebanese blogger & a Master's student in Arabic Literature. She holds a BA degree in business administration & economics (emphasis banking & finance) from Notre Dame University-Louaize since 2013 & is currently working as an accountant in a pharmaceutical company. Nour also pursued a BA degree in Arabic language & literature at Lebanese University & graduated in 2016.

She has a certificate of participation in Journalism course from Annahar academy & a certificate of training on the strategic use of social media from Naharashabab NGO & USAID. This background along with the desire to read books & write articles & poems helped her in starting her blog "nourzahi.wordpress.com" in November 2012.

Very simple things may inspire Nour to write: heavy rains, sunny winter mornings, a talk with a stranger, a great book, music, news, harassments that people face. She is drawn to writing since she believes in the power of words in expressing thoughts & feelings, for that reason she writes about various social subjects. Nour can be contacted at nour.hassanieh@gmail.com.

KATIA AOUN HAGE

Among half torn papers with doodling, toys and Xbox sounds, endless preparations of meals and the constant pull to make connections with everything and everyone around her, Katia Hage redefines the confines of society with colored brush strokes of depth of perception and divine presence. Poetry, calligraphy, painting, music, dance, dreams become the outlet of an intuition belonging to generations of past and present. Her own personal journey in life, from the mountains of Cameroun, to the shores of Lebanon to the valleys of California, leads her back home, a place where the heart, the body and the mind become aware of each other and explode with an energy of recognition and love into words and sounds.

One might recount the acts of going to school, getting a musicology degree and a master's degree in music education, performing in local venues in theater and coffee houses, or the events of marriage and immigration, of war and becoming a refugee, of not having the privilege to be born in one's own country, but what moves Katia as a human artist are the connections that occur at every turn of her life. Her ability to step out of her comfort zone, to open wide her heart and mind to what is offered, takes her on a voyage of extreme delight bathed under the sun to the cliffs of illusion and depression in a dark night. This is what allows her to listen and hear and write the many stories living in her own and other people's bodies, people who become beloved, unique and worthy of every experience and joy.

As she continues to write and perform with local artists, Katia Hage moves through her internal world to build bridges of understanding and love, by touching the places of emotions and witnessing the dignity of every life.

AMAL CHEHAYEB

What are your primary sources of inspiration?

I find inspiration in life; life events such as birth, death, love, heartbreak, rain, sunshine, suffering or jubilation… At times the feelings are too strong to express in prose, and my words come out in poetry, at other times the comedian in me leans toward telling life's humorous trials in stories.

As a stage performer, I found myself able to embody a different persona. I slipped on this role like a dress and enjoyed being on stage; a great feat as I used to have stage fright.

Why are you particularly drawn to the media (poetry, visual art, etc.) you create?

I have been writing since the age of 12. I began keeping personal journals at an early age, and that evolved into writing short stories based on a song I might have heard or made up tales I used to tell my daughter when she was a toddler. Growing up, my family would ask me to sing to them. I used to get so nervous when they asked me to perform for company. Singing to myself brought me joy. I would become lost in my own little world where all that mattered was the tune, and life's woes were left behind.

How has your personal background influenced your art?

My writing changes with my moods. However most of the topics have come from my everyday life. My parents always encouraged me to write, to sing and later to perform. Their support gave me courage to publish some of my work. As I grow older, I find that much of life is actually quite funny and I have noticed that although I am touched by the suffering of others, I found a light hearted side of me that I enjoy expressing.

I have however been unable to sing for the past 5 years. Too much talking in class while teaching elementary school, and raising my voice to be heard over the music while teaching dance, created havoc on my vocal chords. To my chagrin I can no longer hold a note properly, nor do I have the stamina to carry a musical phrase. At first this distressed me to no end, but I have found solace in reliving the memories of being able to belt out tunes and to perform on stage.

PAMELA CHRABIEH

I was born and raised in war-torn Lebanon. My artistic journey started there in the 1990s, during which I studied and practiced Plastic Arts/ Sacred Arts and the restoration of icons. I was looking to formulate a content and express it in the academic, civil society and artistic spheres, mainly on war memory, inter-human dialogue and peace. Restoring a physical icon of the 16th c. C.E. was equivalent to restoring my damaged inner-self and contributing to change within my society. I never stopped believing in the importance of healing individual and collective wounds caused by physical and psychological wars.

This belief still incarnates in my paintings, whether I deal with the issue of women's rights or intercultural/interreligious dialogue. Furthermore, my personal quest for catharsis as a war survivor and my belief in both the inevitability of the transmission of war memories in most private and public contexts and the urgency of a collective healing process that would include all social strata made me acknowledge the input of downplayed narratives and silenced voices in the construction of an inclusive, pluralistic and convivial national memory, history and identity in Lebanon.

Pamela Chrabieh is Lebanese and Canadian. She holds a Ph.D. in Sciences of Religions from the Université de Montréal (Québec- Canada) and is Associate Professor of Middle Eastern Studies at the American University in Dubai (AUD- United Arab Emirates). Author of many books including Icônes du Liban (Carte Blanche – Canada, 2004), A la rencontre de l'Islam (Médiaspaul – Canada, 2006), Voix-es de paix au Liban (Dar el Machreq - Lebanon, 2008) and Womanhood in Western Asia (in Arabic, Dar el Machreq – 2013), she is the founder of the Red Lips High Heels' movement and online platforms.

FRANK DARWICHE

Where things stand is always the question: the one guiding question that goes back to the origin, for asking about things as they are is asking about what anything is in itself.

That has been my guide ever since a semblance of consciousness came about in/as myself.

"Man is question", said R. Coste somewhere, and to that truth I have been true all my life, with ups and downs, deceptions, revelations, joy, sorrow, on and on, over the path of philosophy.

Along this path, thought has always sought its more intimate avenues for me, its closeness to what is innermost, and among such avenues there has been the poetic, not for its aesthetic "value", not for its metre, but for its capacity at letting things be said as they are, along with an unfurling of language's unsuspected power, its sheltering and opening of the essence of things, and thus of myself as here and now and away, as a man, as a woman, as what is for us to be.

From France to England to the USA, to Lebanon, it's always been a journey into what it is to slide and hover above troubled and quiet waters, it's always been a question of what time has allotted and let be, it's always been a reconsideration of what ought to be thought and given forth.

Every word of poetry I've written is weighed, heavily considered and reconsidered, and yet, almost surprisingly, it comes from an intuition, an immediacy in contact with the world and its happenings. Each word has been the site of a hesitation and will hopefully continue to be.

Frank Darwiche holds a Ph.D. in Philosophy from the Université de Bourgogne (Dijon-France) and is Assistant Professor in Philosophy at Balamand University – Lebanon. He is the author of many publications such as: "... vers "le dieu" : le soufisme d'Ibn 'Arabi et la pensée de Heidegger (...toward "the god": Ibn 'Arabi's Sufism and Heidegger's Thought", in Hawliyat, 15/2014; "La tolérance, est-elle garante de la paix (Can tolerance Guarantee Peace?)", in Annales de philosophie et des sciences humaines : solidarité et paix, 31/2014, p. 65 to p. 74; Heidegger : le divin et le Quadriparti (Heidegger: the Divine and the Fourfold), Ovadia Press, Nice, France, May, 2013; "La tolérance : analyse et

limites (Tolerance: analysis and limits)", in *Le Laboratoire*, 2/2012; *"La distance dans l'art contemporain (Distance in Contemporary Art)"*, in *Le Laboratoire*, 1/2011, p. 38 to p. 42; *"Le divin (Göttliche) au cœur du Quadriparti (Geviert) (The Divine at the heart of the Fourfold)"*, in *La revue philosophique de la France et de l'étranger*, 3/2009, p. 309 to p. 332; *"Hegel et Heidegger : vers le dieu (Hegel and Heidegger: Towards the god)"*, in *Klèsis*, 15/2010, p. 69 to p. 88; *"Introduction à une étude originelle de l'éphémère (Introduction to an Original Study of the Ephemeral)"*, in *Sciences humaines combinées*, October 2007; *"Lebanon"*, in *Countries and Their Culture*, New York, MacMillan, Yale, 2001. Soon to be published: *Le Liban ou l'irréductible distance (Lebanon or the Insuperable Distance)*, Vermifuge, France; *"Le Summum ens et la différence : Heidegger et Saint Thomas d'Aquin (The summum ens and difference : Heidegger and St Thomas Aquinas)"*, USEK Press, Lebanon.

MAYA KHADRA

Maya Khadra, née au Liban en 1990, est activiste pour la cause de la citoyenneté dans le monde arabe à travers l'organisme régional CAFCAW où elle occupe le poste de coordinatrice de projets et membre exécutif, journaliste et critique littéraire, engagée pour la cause féminine surtout au Moyen Orient et est l'auteur de deux ouvrages littéraires: "Moi en Sépia" et "Derniers jours d'une nymphomane", ainsi que d'une publication académique dans l'ouvrage collectif "Shifting Identities in the Arab World". En 2013, elle obtient le 1er Prix du journalisme francophone illustré en zones de conflits. Installée depuis un an à Paris, elle est en cours de préparation de son doctorat en littérature francophone du Proche Orient (Liban, Palestine et Syrie).

SANDRA MALKI

What are your primary sources of inspiration?

Pain has always been my source of inspiration. I cannot even write a normal sentence when I am happy, but when I am angry, sad or completely crushed then I transform to an author and a poet. Don't ask me why. I have had this "gift" since I was a little girl. I wrote my first poem at the age of seven and all teachers I've had have been amazed by how I can completely fail at assignments at school that don't mean anything to me but master others that touch a nerve in me or makes my heart skip a beat. I have no idea how to get rid of this "gift" because I never had a reason. Happiness is a rare, almost alien subject to me, so I will continue to write as long as it is absent in my life. The day I find happiness is the day I will stop writing. Not because I want to, but I have no idea of what to write when happy.

Why are you particularly drawn to the media (poetry, visual art, etc.) you create?

I am not drawn to the particular subject I write about, it is drawn to me. It has always existed in my life. I wish it wasn't the case. I wish one day I will get rid of the source of all my poems and lyrics: honor culture. It is, to me, the most hateful and the most evil crime anyone can ever commit. To totally disgrace another human being like that, why? I never understood how cruel a person can be when honor culture is used to completely destroy another human being and call it honor. For me it is a mystery, a puzzle I will never be able to finish because I will never understand the whole picture. My eyes are made to see freedom, not captivity!

How has your personal background influenced your art?

My personal background has everything to do with my writing. Every word I write, every letter, every punctuation, is from every scar I have, every tear that I cried, every injustice I faced. Not a single word is fabricated or dramatized or up scaled. It's all there, in the lines I write, between the lines as well when it is too painful to use the full information or too sensitive. When I need to protect myself or someone else then my words can sometimes be confusing but I think the people who live or lived with honor culture will understand every unwritten word and hear the tears behind some humorous sentences. I know you know. Because you see, I don't only write for me. I write

for you too.

OMAR SABBAGH

Omar Sabbagh is a widely published poet and critic. Two of his extant collections are: *My Only Ever Oedipal Complaint* and *The Square Root of Beirut* (Cinnamon Press, 2010/12); *To The Middle of Love*, his fourth collection, is forthcoming with Cinnamon Press in January 2017. His Beirut novella, *Via Negativa: A Parable of Exile* was published by Liquorice Fish Books in March 2016. A Dubai sequel to the latter, *From Bourbon to Scotch,* is forthcoming in 2017 with Eyewear. He has published or will have published scholarly essays on George Eliot, Ford Madox Ford, G.K. Chesterton, Robert Browning, Henry Miller, Lawrence Durrell, Joseph Conrad, T.S. Eliot, Basil Bunting, Lytton Strachey, Hilaire Belloc, and others; as well as on many contemporary poets. His latest book is a collection of critical essays on literature, *Disciplined Subjects and Better Selves* (Anaphora, September 2016). He now teaches at the American University in Dubai (AUD).

The source of most of his creative work, and indeed much of his critical work – viewed as just as creative – is himself. As a lyric poet in the main, he tends to find, via his poetry, objective correlates of his state of mind and feeling; as a prose writer, in fiction and/or nonfiction, he tends to use himself as a sounding board for insight. In other words writing the 'other,' for him, is a reflection of self-understanding, often enough. Having a very British mind – his heart and soul remain Lebanese and Arab. And this means that while the English language is felt by him as a part of his body, forcing him and compelling him to deploy it, to body it forth – none the less, the hope remains that unlike many contemporary British writers, he writes with a burly quotient of soulfulness. Words, his medium, are extensions of his self and, true narcissist that he is, also the means to continuously and unendingly 'prove' that he exists.

JOELLE SFEIR

What are your primary sources of inspiration?

I write on subjects that matter to me - social issues, and mainly women's rights. When I write, it is usually because a specific matter has been eating up at me for a while, turning and turning in my head, almost like an obsession. It makes me see all things related, and the links to what is troubling me are highlighted in my mind. I see the connections like lines of light; connections and lines that create a network in social issues that mean a lot to me. I reflect for a while and feel the immense urge to express these thoughts. I use words to help me ascend from an emotional state to a more rational one, hoping that my thoughts will eventually bend the course of things to a better one (of course, this will only be done when all think alike, which is not yet likely).

Why are you particularly drawn to the media (poetry, visual art, etc.) you create?

I love words. I love to play with them, to use them and abuse them. I love how one word can mean so many different things, how i always have to make sure the listener/reader is getting what I mean by a certain word. I love to learn and know the different meanings the same word can have in different settings and/or cultures.
When I need to express something, words are "my thoughts and emotions in action".

How has your personal background influenced your art

As an Arab woman, I live in a world where sexism, machismo and patriarchy are omnipresent. Having been brought up in a more "open minded" family and having lived 10 years in Canada, I have learned about a totally different culture, and a different "public discourse" regarding women's rights. Like many other women, I have always been confronted to different sets of realities, and double standards. With this in mind, all that I see is always, one way or another, linked to the double standards issue that I see reflected in so many social justice issues - racism, homophobia, gender, etc.

ABOUT *REEDS FOR RED LIPS*

What influence does gender have on art production in nowadays Southwestern Asia? Does gender embody everyday life experiences, including the artistic experience? Are gendered spaces of the region Orientalized, demystified, or both? Are bodies, especially women bodies, described asexualized, passive and silent? Do local authors and artists living in diaspora reproduce totalizing or essentialist tendencies? Are power relations between the former colonizers and colonized uncovered? Has the aftermath of the so-called Arab Spring given women a greater voice and are more individuals willing to talk about gender openly? Is the view that assumes that women in Southwestern Asia are oppressed and left out of cultural debates a misconception?

In her anthology Reeds from Red Lips, Pamela Chrabieh explores these questions through stories told from a wide spectrum of voices, all from artists who dream of peacebuilding, human rights, and women's rights in Southwestern Asia.

Authors and Artists
Pamela Chrabieh | Norah Al Nimer | Katia Aoun Hage | Malak El Gohary | Amal Chehayeb | Lana AlBeik | Frank Darwiche | Noor Husain | Joelle Sfeir | Maram El Hendy | Omar Sabbagh | Karma Bou Saab | Farah Nassar | Haeley Ahn | Masooma Rana | Sandra Malki | Maya Khadra | Nour Zahi Al-Hassanieh